POSTCARD

Mohawk Trail

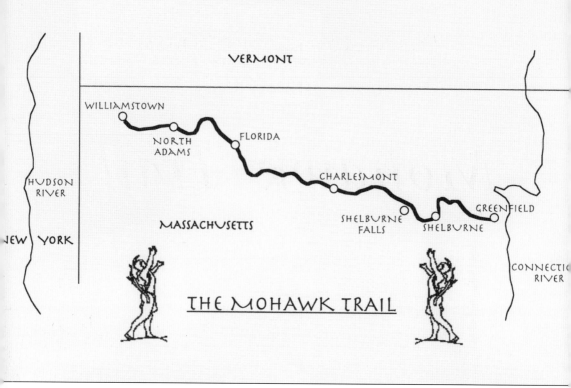

Pictured here is a map of the Mohawk Trail.

POSTCARD HISTORY SERIES

Mohawk Trail

Robert Campanile

ARCADIA
PUBLISHING

Published by Arcadia Publishing
Charleston SC, Chicago IL, Portsmouth NH, San Francisco CA

Printed in the United States of America

Library of Congress Catalog Card Number: 2006940624

For all general information contact Arcadia Publishing at:
Telephone 843-853-2070
Fax 843-853-0044
E-mail sales@arcadiapublishing.com
For customer service and orders:
Toll-Free 1-888-313-2665

Visit us on the Internet at www.arcadiapublishing.com

Dedicated to earth, air, fire, water

CONTENTS

ACKNOWLEDGMENTS

Experiencing both the natural and human history of the Mohawk Trail has always been something I felt fortunate to have within reach. To author a book about this amazing stretch of beauty and ancient events is a privilege. I am sincerely grateful to Arcadia Publishing and its professional staff for allowing me this precious opportunity. I realize there are many minds involved in the workings and production of such a book, but one's editor always deserves a special note. Thank you, Erin Stone, for once again creating a positive, supportive, and comfortable atmosphere for such an endeavor.

The guts of this book, the images that take the reader visually through the journey, are the product of the North Adams Historical Society's generous cooperation and use of its extensive vintage postcard collection. A precious few are also from the personal collection of Justyna and Gene Carlson. The society's old and rare book archives provided the many interesting sources for my research and for the wonderful covers portrayed in chapter 10. A special thanks goes to society president Charles Cahoon for revealing to me some unique and adventurous nooks and crannies on the Mohawk Trail. Also helpful were the Milne Library in Williamstown, the Williamstown House of Local History, and the Williams Inn. Edward Morandi, Marcia Sarrouf, and Darrell English also helped with information. I would be remiss if I forgot to acknowledge all those Native American moccasins that made the Mohawk Trail a reality eons ago.

The joy of accomplishment is only worth it if you have someone to share the joy with. I thank all my supportive friends in North Adams, Williamstown, and my old hunting grounds of New York City for permitting me to share my joy with them.

Lastly I thank my family for the support and love that generates the courage and ambition to take on all challenges.

INTRODUCTION

Any story that has the ingredients of "ancient" and "mystery" mixed in is a story that is captivating. The history of the Mohawk Trail has as many curves as the path itself. Essentially a product of Native American history and legend and modern American engineering, the only real certainty is that it exists. How much the modern Mohawk Trail reflects or replicates the footsteps of the ancestral Native Americans is a debate left to historians and folklore enthusiasts. There is certainly enough evidence of native footpaths that logically followed the persuasion of the environment or the path of least resistance. The Native Americans would naturally follow rivers, streams, and the edges of forests to make their journey efficient and with speed. The first settlers would conveniently follow, alter, and extend these narrow pathways for their own use and agenda. Modern settlements would tend to wipe away many remnants of the original trails either out of ignorance, lack of historical interest, or just because the trails were unrecognizable. Later, rather than sooner, there comes a time when historians and the curious want to reconstruct the past long after most of it has been dismantled. To some extent, the Mohawk Trail was one of those ancient footpaths that would occupy the minds of modern settlers long after the originators of those paths were gone. Where were the original trails? What was their length? Where did the trails come from and lead to? Is the modern Mohawk Trail true to the old one? Is it appropriately named? Ultimately, no one has a definitive answer to all these questions, but many have some interesting ideas and conclusions. Three things seem to be certain: the original native footpaths are essentially erased from the landscape but once extended clear across the state of Massachusetts from east to west and probably originated in New York; the roads of the later settlers that replaced the ancient trails had different needs and agendas so they followed their own paths and needs; and in the early 1900s, mainly through the effort of people in North Adams, a modern Mohawk Trail emerged that celebrates both the ancestral spirit of the first Americans and the modern engineering prowess of contemporary America.

The history of the Mohawk Trail is a part of the legacy of the Native Americans who inhabited the valleys from the Hudson River in New York to the valleys of the Deerfield and Connecticut Rivers in Massachusetts. The trail marked the main route between these two destinations in times of peace as well as in times of war by the members of the Five Nations of eastern and central New York and that of the Pocumtucks of the valley of the Connecticut. Various Abenaki, Algonquian peoples, and Mahicans also inhabited the region between these valleys.

The Mohawk Trail is said to follow the routes taken by the powerful Mohawks from the Hudson Valley as they took their raids east against the New England tribes. After the assassination of a Mohawk chief acting as a peacemaker to the Pocumtucks, the Mohawks retaliated and

eventually won the day. Many say this victory and their powerful legacy gave them naming rights for the trail. The knowledge of the trail's origins is obscure, and that obscurity was destined to fascinate people through the years. Before 1590, the history of the trail is lost in the mists of time. But for at least a century or more, the footpaths were trodden with the footprints of Native Americans and history was theirs until the settlers came in the 1700s and made new prints in the soil, those of hoofs and wheels. The stagecoach route made its dents in the 1800s until finally a new creature with rubber tires and four wheels sealed the destiny of a new modern Mohawk Trail created in 1914 that would try to re-create what the Native Americans had always known. It was the most inspiring scenic path one could experience.

Using the aesthetic appeal of the vintage penny postcards of the early 1900s, this book follows the modern Mohawk Trail from the early 1900s to the 1950s. Starting at its westernmost point in Massachusetts in Williamstown, the journey follows the trail's course east through North Adams, up and over Hoosac Mountain, through Florida, Charlemont, Shelburne, and Shelburne Falls, and ending at the eastern terminus in Greenfield and Gil. The postcards paint a portrait of the lingering spirit of an ancient people and a history constantly being redefined and rediscovered by the future.

For those who have taken the trail before, these images will urge you to return. For those who routinely travel the trail, these images will inspire you to take a closer and more appreciative look. For those who have never set foot or wheel on the trail, these images will make the journey irresistible.

Robert Campanile
January 2007

One

Go East, Young Man, through Williamstown

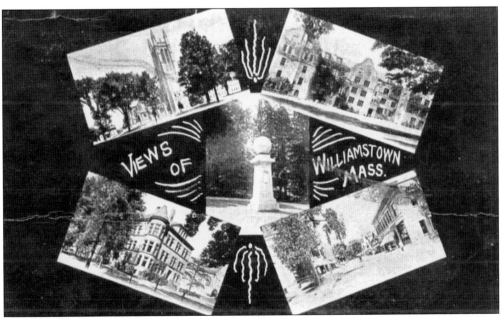

The modern Mohawk Trail begins at the westernmost point in Massachusetts in Williamstown. The town was founded in 1749 and incorporated in 1765. It is the first to greet the trail traveler from the west and the last to bid farewell from the east. The town's elegance expresses itself through both landscape and architecture. The modern Mohawk Trail splices through the spacious Williams College campus. The postcard shows, clockwise from top left, Thompson Memorial Chapel, Morgan Hall, Spring Street, and Hopkins Hall.

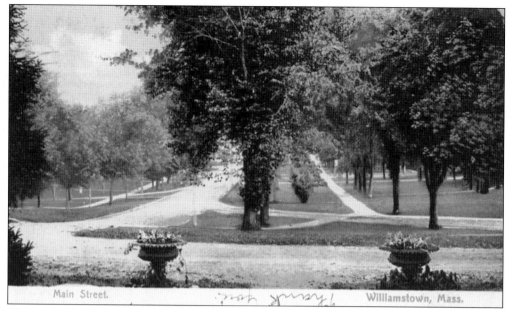

Main Street. Williamstown, Mass.

The original Mohawk Trail is said to have started at a point on the east bank of the Hudson River in New York, then east to the branch of the Hoosac River, through the towns of Hoosac, New York, Pownel, and Vermont, and entering Massachusetts through Williamstown. The modern Mohawk Trail runs down Main Street (Route 2), as seen here in an early postcard view facing east.

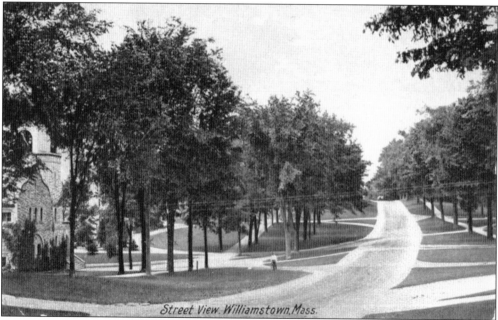

Street View. Williamstown, Mass.

The Mohawk Trail, as seen here facing west on Main Street, was essentially the main route between the valley of the Hudson River in New York and the valley of the Connecticut River in Massachusetts. It represented the path used in times of peace as well as in times of hostilities between the natives of the Five Nations of eastern and central New York and the Pocumtucks of the Connecticut Valley with the Abenaki, Algonquians, and Mahicans also in the region.

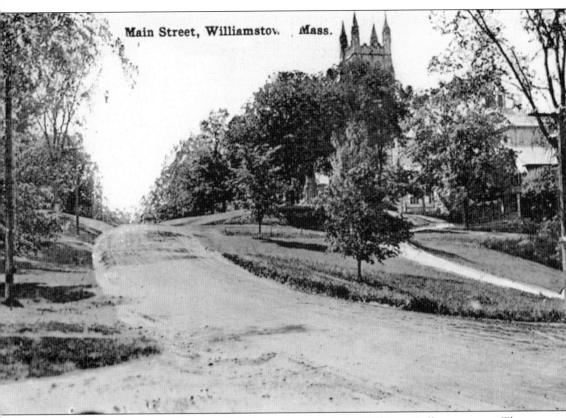

Main Street, Williamstown, Mass.

This view of the trail on Main Street is facing west toward the Williams College campus. The church tower is Thompson Memorial Chapel. In time, the Mohawk Trail and its extensions would become part of the main thoroughfare between Boston and Troy, New York, and transform into more of a highway than a path.

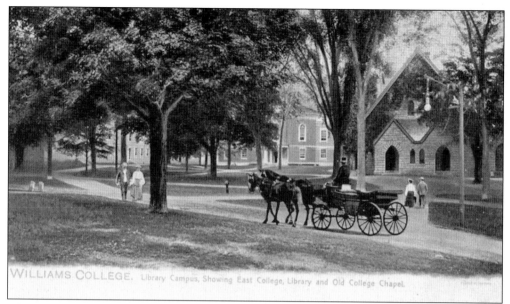

WILLIAMS COLLEGE. Library Campus, Showing East College, Library and Old College Chapel.

The initial stretch of the Mohawk Trail in Williamstown divides the Williams College campus. Williams College owes its name and its origins to an educational bequest of Col. Ephraim Williams (who was killed at the Battle of Lake George in 1755) for the purpose of founding a "free school" in Williamstown. Through the trees in the postcard are seen, from left to right, the East College Building, the library, and the old college chapel.

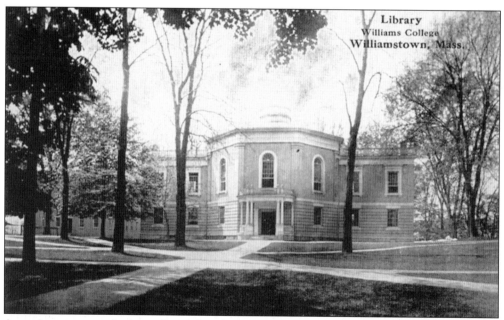

Library
Williams College
Williamstown, Mass.

Amos Lawrence was in the audience for a lecture by Williams College president Mark Hopkins in Boston. He was so impressed he became a benefactor for the college even though he had never seen it. This Lawrence Library building was one result of his generosity. It opened in 1846. The postcard shows the two-wing extension that was added to the original building by the late 1800s. Today the structure serves as the home of the Williams College Museum of Art.

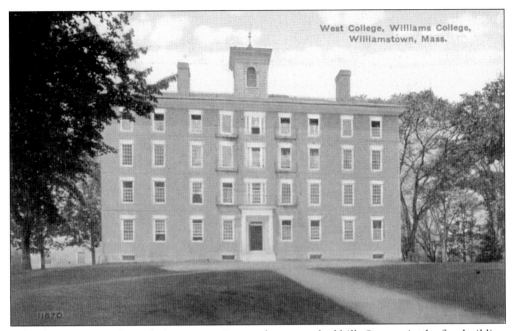

As the trail runs east through the campus, it ascends up a gradual hill. On top sits the first building of Williams College, the West College Building. The college was chartered in 1785. Before long, it would have a four-story brick building with its first live-in students. On October 26, 1791, the "free school" admitted 45 scholars.

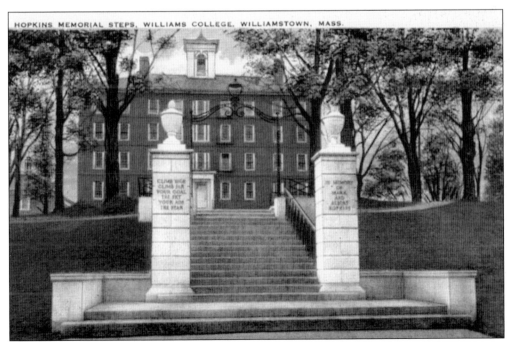

In front of the West College Building are the Mark Hopkins Memorial Steps honoring the man who was the college's fourth president, in 1836. The plaque on the left pillar reads, "Climb High / Climb Far / Your Goal the Sky / Your Aim the Star."

13

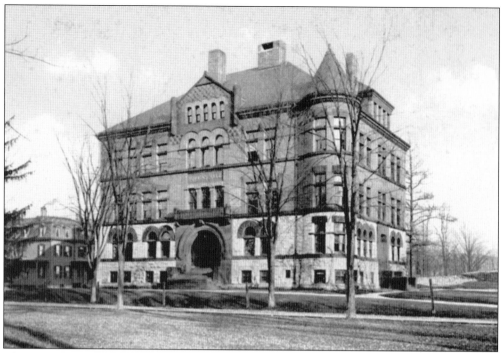

This postcard shows Hopkins Hall, built in 1890. Mark Hopkins was referred to by some as the college's "Man of the Century." The trail through the campus is a literal architect's dream highway as witnessed by these magnificent structures.

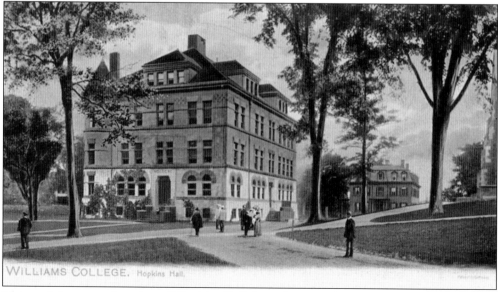

This card shows another view of Hopkins Hall from the rear side.

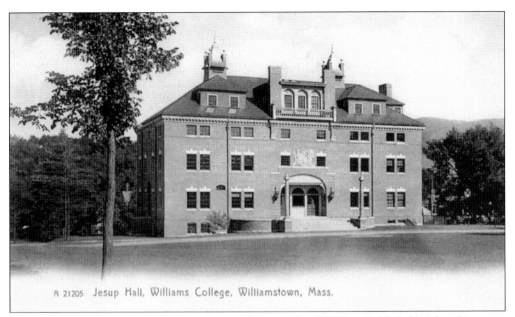

A 21205 Jesup Hall, Williams College, Williamstown, Mass.

The Williams College buildings on the trail have a splendid mix of old Colonial architecture and reproductions of Gothic and Georgian styles. Jesup Hall was built in 1899 and is named after Morris K. Jesup, a prominent New York banker and manufacturer.

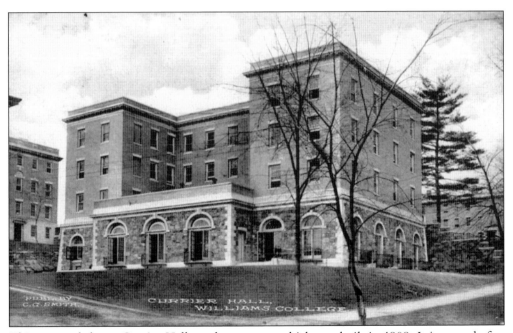

This postcard shows Currier Hall on the campus, which was built in 1908. It is named after Lura Currier, the widow of Nathaniel Currier of Currier and Ives fame.

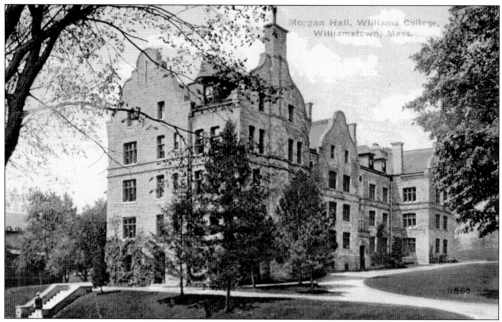

Morgan Hall was built with a $100,00 donation by Edwin Denison Morgan, who was the governor of New York in 1859. This dormitory was built in 1883.

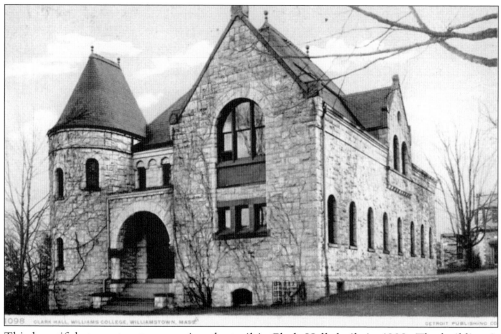

This beautiful stone structure gracing the trail is Clark Hall, built in 1908. The building is named after Edward Clark from the class of 1831, and it is part of the science complex.

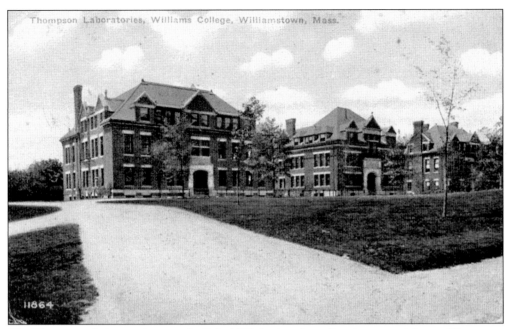

The Thompson Laboratories were built in 1893 during the college's centennial year. They were financed by the benefactor Frederick Ferris Thompson and house the biology, chemistry, and physics laboratories.

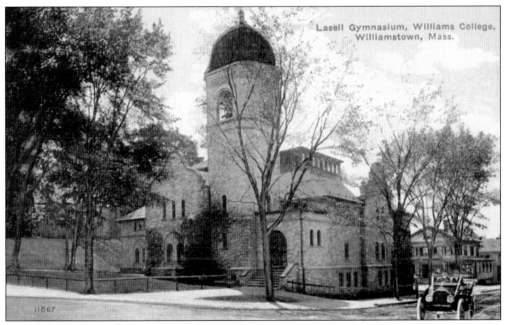

Lassell Gymnasium is a dramatic towered building on the trail that was built in 1886 from a donation by the Lassell family in memory of Edward Lassell, the college's first chemistry professor.

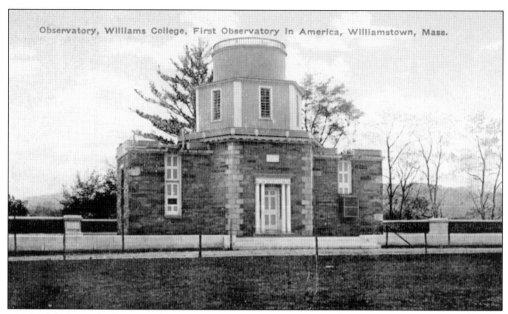

Observatory, Williams College, First Observatory In America, Williamstown, Mass.

Hopkins Observatory, erected in 1837, was the second college observatory built in the United States. It is currently the oldest functioning observatory in the United States. It was built from flint stone quarried nearby and cost only $2,075. It is a reminder that the very same heavens the students observe today is the same viewed by the Native Americans who traveled through this vicinity centuries ago.

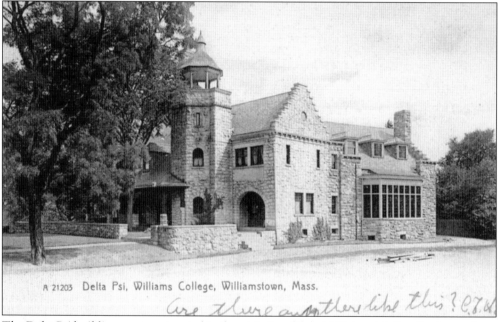

A 21203 Delta Psi, Williams College, Williamstown, Mass.

The Delta Psi building was constructed in the vicinity of the old Nehemiah Snedley house from the 1760s. It was from this house that the women of the town baked bread for the men who had just arrived via the trail to gather in Williamstown to fight off the approach of the Hessians at the Battle of Bennington just over the border in Vermont. Mrs. Snedley sent her 16-year-old son into the battle with the bread.

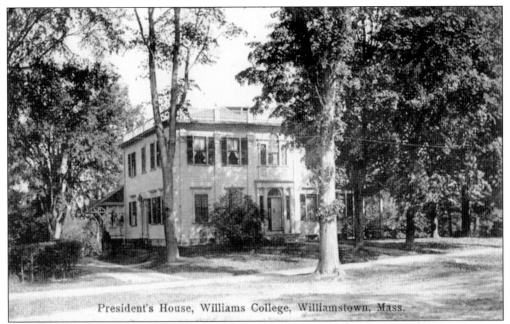

President's House, Williams College, Williamstown, Mass.

Gen. Samuel Sloan, a blacksmith, kept a tavern at the Five Corners in North Adams (where the modern trail crosses with upper East Main Street, which is the old Mohawk Trail) and also built an elegant house (in 1801) for himself in Williamstown on the main street (today's trail). His son attended Williams College, and eventually the house would be used as the president's residence from the college's fourth president (Mark Hopkins) on.

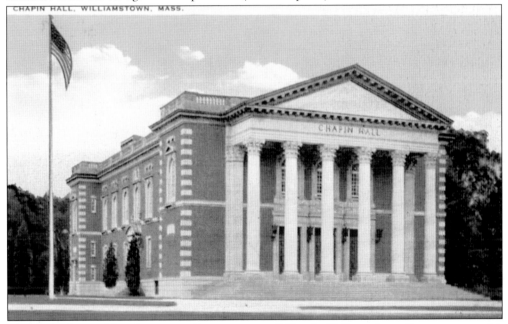

CHAPIN HALL, WILLIAMSTOWN, MASS.

This is the beautiful and commanding presence of Chapin Hall on the college campus with its classic Greek design front. It is named after Alfred Clark Chapin of the class of 1869, who became a generous benefactor of the college. Among the posts that he served while in New York was the mayor of Brooklyn in 1887.

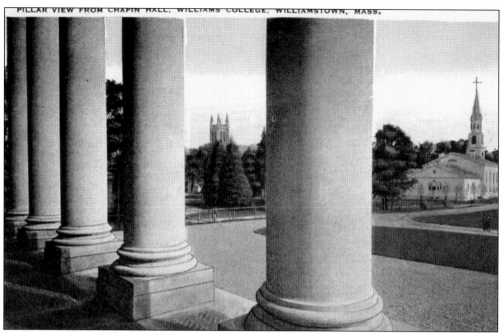

This postcard shows a view from the front steps of Chapin Hall facing toward the Mohawk Trail (Main Street/Route 2). The tower in the center of the image is Thompson Memorial Chapel, and the steepled church on the right side is the First Congregational Church. Both are located on the trail.

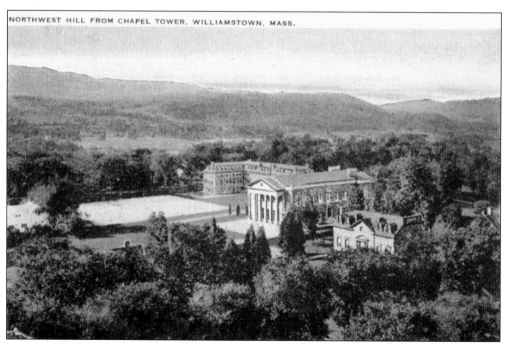

NORTHWEST HILL FROM CHAPEL TOWER, WILLIAMSTOWN, MASS.

This is another stunning view of Chapin Hall and the area of the campus surrounding the building, taken from the viewpoint seen in the tower of Thompson Memorial Chapel. This is on the trail and facing north toward New York to the left and Vermont to the right.

20

Thompson Memorial Chapel on the Williams College campus was built in 1905. This majestic Gothic structure was funded by the family of the college's lifelong benefactor Frederick Ferris Thompson. It was referred to as a "majestic and enduring symbol of the democratic Catholic faith of Williams College."

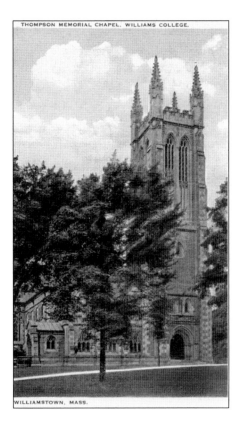

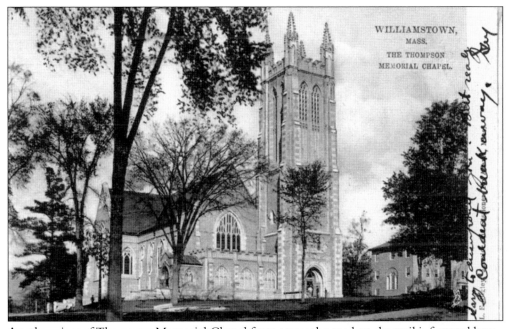

Another view of Thompson Memorial Chapel from across the road on the trail is featured here.

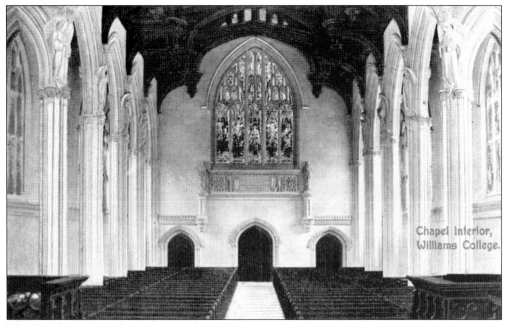

This postcard shows the cathedral atmosphere and the exquisite stained-glass windows of the interior chapel of Thompson Memorial Chapel.

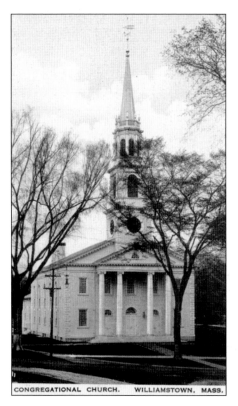

Gracing the trail on the college campus with its New England steepled church is the First Congregational Church with its attractive clock tower. The church parish was organized with the village in 1765 and met in four different meetinghouses before the present structure was built in 1914, the same year the modern Mohawk Trail opened.

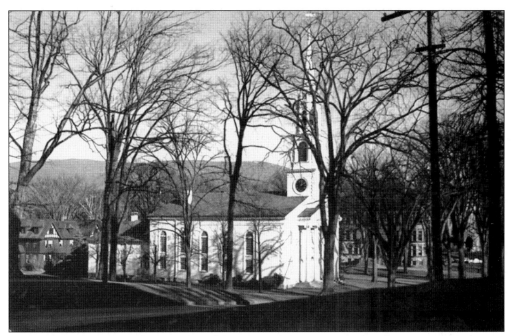

This postcard shows a different view of the First Congregational Church.

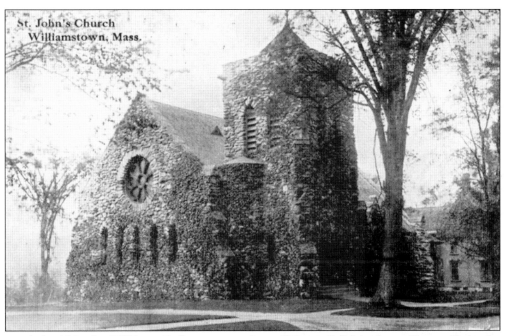

Nestled within the Williams College campus just off the trail (Main Street/Route 2) sits the cozy St. John's Church with its simple yet strong stone architecture. The first gathering of the faith was on Christmas Day in 1853 by Williams College students. They agreed to continue to meet in private homes and, in time, organized a parish in 1894. This church was built over an old mission house and opened in 1896.

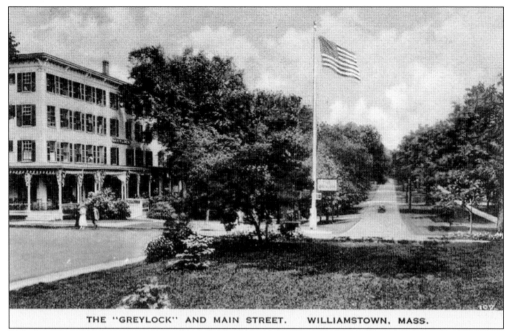

THE "GREYLOCK" AND MAIN STREET. WILLIAMSTOWN, MASS.

The Mohawk Trail would always be a great location to start a business offering shelter, food, and, in later years, gifts and souvenirs. The Greylock Hotel was on the northeast corner of North and Main Streets and was an elegant place. It opened close to the time when the official trail opened in 1914.

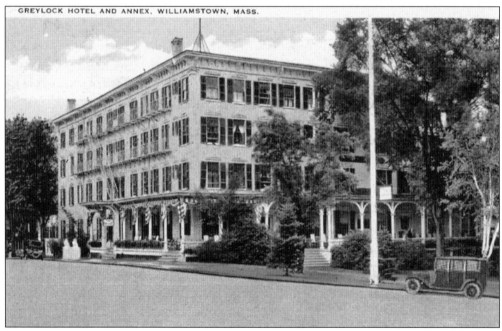

GREYLOCK HOTEL AND ANNEX, WILLIAMSTOWN, MASS.

This postcard shows the Greylock Hotel with its splendid and inviting wraparound porch. Although popular and prominent, its legacy did not get it through the Depression years, and it succumbed to the weight of the stock market crash.

24

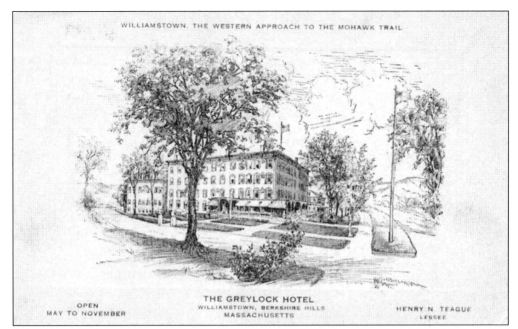

Another postcard shows the Greylock Hotel in the form of a sketch of the beautiful building. At the top of the card it notes Williamstown as the "western approach to the Mohawk Trail." The owner, Henry Teague, was said to be the one who came up with the phrase "the Village Beautiful" as the alias of Williamstown, and no one has ever disputed its legitimacy since. The back of this postcard contains a poem by that title by Clara E. Hill from Buffalo, New York.

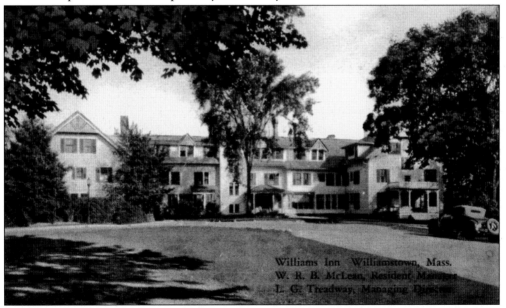

Today's prominent hotel is the Williams Inn located at the western head of Main Street at the entrance to the trail in town. The Williams Inn was founded in 1909. It provided a year-round hotel near the college campus but was originally located, as seen in this postcard, off Southworth Street. The present location on Main Street opened in 1974. The postcard shows the original inn as it looked in 1938.

25

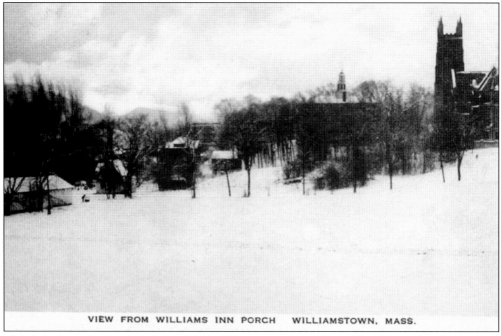

VIEW FROM WILLIAMS INN PORCH WILLIAMSTOWN, MASS.

This is a view of winter on the trail in Williamstown from the porch of the old Williams Inn. The tower in the upper right corner is Thompson Memorial Chapel on the trail.

This is a postcard of the present Williams Inn located on the western end of Main Street at the intersection of Route 7 and Route 2 (the Mohawk Trail). It is located on the former site of the West Hoosac Stockade and Blockhouse, which was built in March 1756 and served to defend the area from the French and Native Americans. A plaque on the grounds tells of an attack by Native Americans on July 11, 1756, which was repelled despite three scalpings. (Courtesy of the Williams Inn.)

26

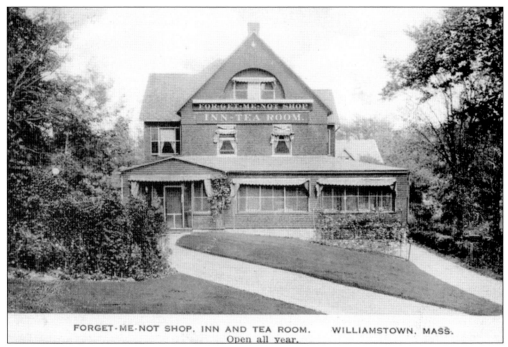

FORGET-ME-NOT SHOP, INN AND TEA ROOM. WILLIAMSTOWN, MASS.
Open all year.

The Forget-Me-Not Shop, Inn and Tea Room was also located on the trail on Main Street just at the edge of the eastern end of the college campus. It began its service on the trail in 1912. Following World War II, the building was taken over by Williams College for housing.

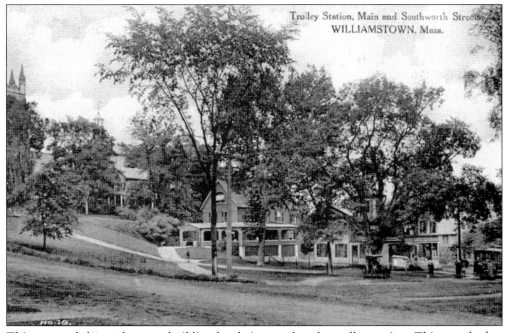

Trolley Station, Main and Southworth Streets,
WILLIAMSTOWN, Mass.

This postcard shows the same building but being used as the trolley station. This was the last stop for the streetcars that ran the trail between North Adams and Williamstown from 1895 to the 1930s.

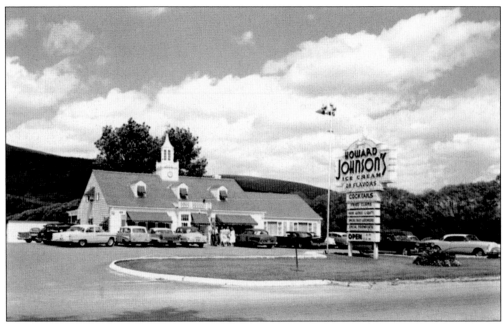

Moving east down the trail toward the city of North Adams, another popular spot from the 1930s to 1950s was the famous Howard Johnson restaurant chain. This cheery building would later become a remodeled (but still recognizable remnant) home for a bank.

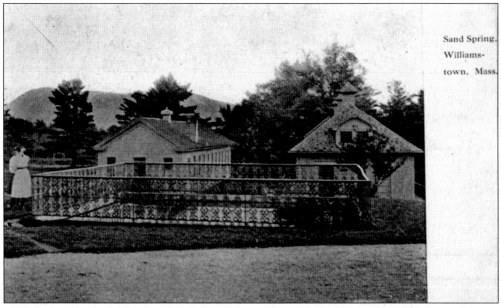

The original native footpaths in Williamstown are believed to be just north and parallel to the modern trail on Route 2. Near that path, now called Sand Springs Road, is the Sand Springs. The waters had a curing and medicinal effect that was recognized and cherished by the Native Americans of the area, and it became a spot frequently visited and used even before the first settlers arrived.

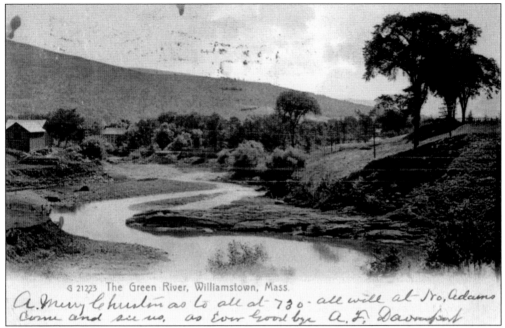

G 21223 The Green River, Williamstown, Mass.

A Merry Christmas to all at 730. all well at No. Adams Come and see us, as ever Good bye A. F. Davenport

Most of the original trail seems to follow the vicinity of the riverbanks and probably crossed over from side to side to follow the landscape of least resistance. This is why there is never a river or stream very far from the trail. There are two prominent rivers that cross over (or in modern times under) the trail in Williamstown. The primitive and winding Green River is shown in these two postcards. The river meanders through southern Williamstown and crosses the Mohawk Trail just past the Williams College campus.

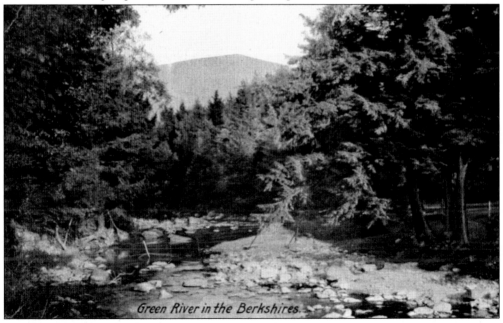

Green River in the Berkshires.

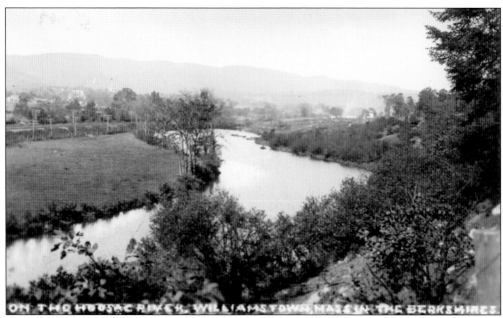

ON THE HOOSAC RIVER, WILLIAMSTOWN, MASS IN THE BERKSHIRES.

The main river that the Mohawk Trail follows and crosses in western Massachusetts is the Hoosac River. The river flows west through both Williamstown and North Adams. The Hoosac River crosses the trail several times as it twists and turns on its journey with its companion trail through both city and town.

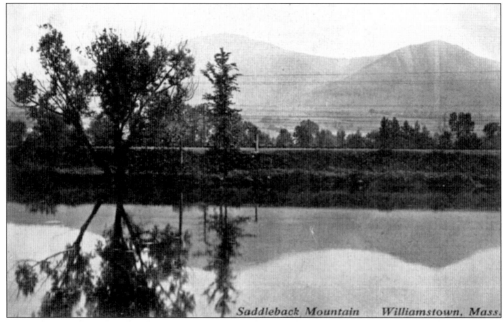

Saddleback Mountain Williamstown, Mass.

As the modern Mohawk Trail leaves Williamstown behind and crosses over into North Adams, the dominant backdrop on the landscape is the voluptuously shaped Saddleback Mountain, which stretches its bulk parallel to the trail and transforms the town atmosphere into a rustic country setting before the city center of North Adams, just a few miles east, takes over once again.

Two

HOME OF THE
MOHAWK TRAIL

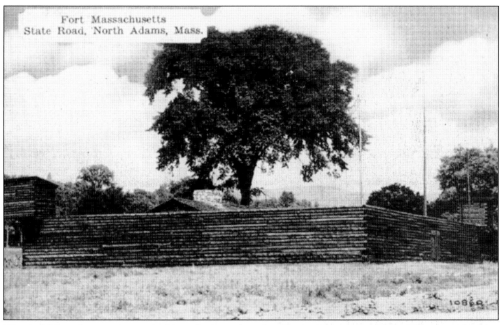

The initial and most dramatic historical marker that is encountered as the trail enters the city of North Adams is the site of Fort Massachusetts. This place reminds the traveler that this now peaceful valley was once a battleground of hostilities as the French, English, and Dutch all made bids for its possession. This postcard shows the 1933 replica of the fort built on what is believed to be the original site. Today all that remains of this fort is the barracks room stone chimney and a commemorative plaque. (Courtesy of Justyna and Gene Carlson.)

The original Fort Massachusetts was the scene of a siege that occurred on August 19, 1746, by the French and their Native American allies to capture the fort, which was being defended by about 22 people, including militia, women, and children. The Mohawk Trail would have seen over 900 French and Native Americans advancing on the fort from the west. The trail would have been traveled by the men who came to build the fort and defend it. Fort Massachusetts was a consequence of two factors—defending the area from attacks from the west and warning the infringing Dutch settlers to stay away. This postcard is of the 1933 replica.

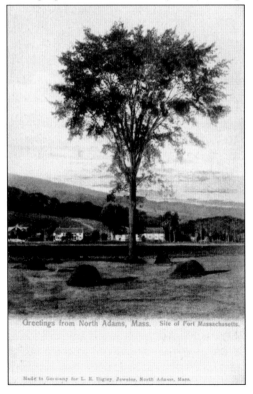

Greetings from North Adams, Mass. Site of Fort Massachusetts.

Made in Germany for L. K. Higley, Jeweler, North Adams, Mass.

The battle for Fort Massachusetts is one of the most dramatic and romantic incidents on the trail. The fort was the westernmost of a chain of four forts for the defense of its frontiers by the Massachusetts Bay Colony. This tree (known as the Perry Elm, named after the Williams College professor who studied the fort) marks the spot where the fort used to stand before the replica was built in 1933. The original fort was burned down by the French after their successful siege in 1746. (Courtesy of Justyna and Gene Carlson.)

This postcard shows the Elisha Nims monument inside the 1933 replica of Fort Massachusetts. Nims was a casualty of a Native American raid outside the fort some months before the siege. (Courtesy of Justyna and Gene Carlson.)

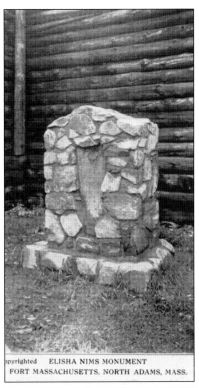

opyrighted ELISHA NIMS MONUMENT
FORT MASSACHUSETTS, NORTH ADAMS, MASS.

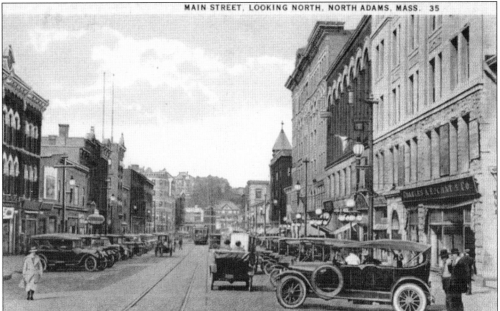

North Adams is the only city located on the trail and was the catalyst that sparked the modern Mohawk Trail project. The city initiated the idea, and eventually the state provided for the building of the modern version of the trail. While today a bypass for Route 2 around the center of the city takes the original modern trail with it, the 1914 version of the trail took it straight down Main Street as shown in this postcard.

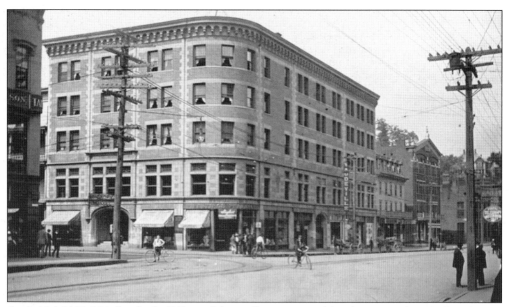

An initial $100,000 for the building of the trail was secured by the Massachusetts legislature, and in late 1912, a survey was made for the Mohawk Trail automobile byway over Hoosac Mountain just east of the city center. Meanwhile, since tourism would benefit from such a project, North Adams hotels would certainly benefit as well. This postcard shows one of the more famous located on the trail (Main Street), the Richmond Hotel. It held the banquet for the dedication of the Mohawk Trail on October 22, 1914.

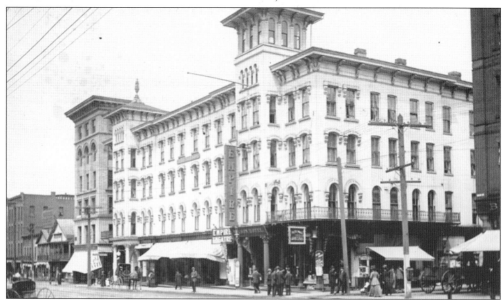

The Wilson House Hotel was another of the dominant structures on the Main Street trail. This early-1900 postcard shows Main Street as a stark contrast to the early days of the old trail when the city was just starting to be settled. Just after the American Revolution, tree stumps left from the original pine forest cluttered the trail that was to be Main Street. It took a town gathering to clear the road, and the man in charge, Joriah Holbrook, remarked, "Any man who fought at Bennington is not to be frightened by an army of stumps."

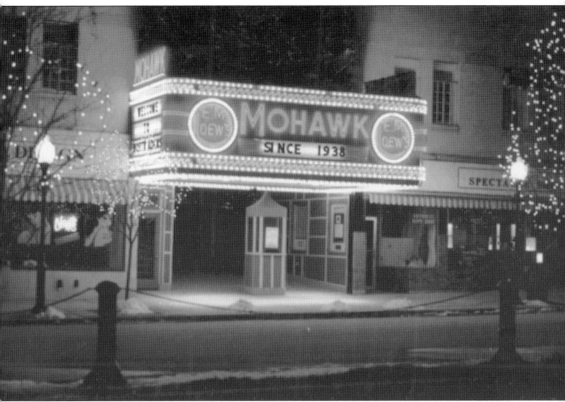

No place has a more legitimate claim to the title "Home of the Mohawk Trail" than North Adams. The modern Mohawk Trail began in 1909 when a North Adams city engineer, Franklin Locke, came up with the proposal of putting a modern road over Hoosac Mountain following the old Native American footpaths. Eventually the idea succeeded and construction began in 1912, and some say a local businessman, Clinton Richmond, came up with the idea to call this new highway the Mohawk Trail. Keeping with that tradition, many businesses would use the name, as shown in this image of the Mohawk Theater. The movie theater opened on Main Street on the trail in November 1938. As of 2007, it stands vacant as it hopefully awaits a new birth of activity sometime in the near future. (Photograph by Robert Campanile.)

This postcard is of Monument Square at the east end of Main Street in the city's center. To pick up the Mohawk Trail today, since it is presently located on the Route 2 bypass, a traveler would follow the street (North Church Street) to the left of the Civil War soldiers' monument. The 1914 trail ran down Main Street and included this monument.

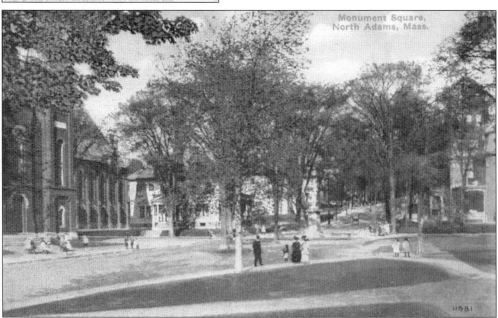

This image shows the Main Street path of the Mohawk Trail as it ran through Monument Square and continued up the hill of East Main Street, which is the road leading off to the background to the right of center. The trail of 1914 continued up this hill, which eventually led to a road up Hoosac Mountain. Today East Main Street still reconnects to the Route 2 trail at the top of the hill where the adventurous and beautiful ascent of the mountain road begins.

Three

TURN, TURN, TURN

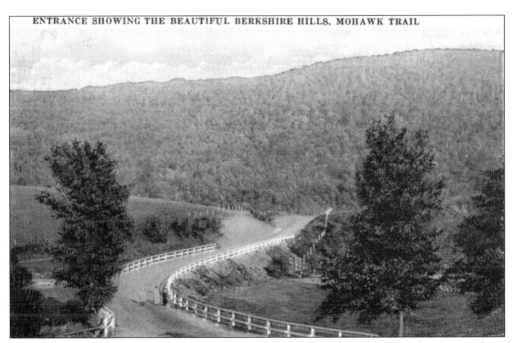

ENTRANCE SHOWING THE BEAUTIFUL BERKSHIRE HILLS, MOHAWK TRAIL

The winding Mohawk Trail leads east out of the center of North Adams and slowly ascends up the side of Hoosac Mountain. Because the trail linked two lower valleys by scaling the almost impassible mountain range that towered over 1,500 feet, both the Hoosac (also known as the "Forbidden Mountain" and "Spirit Mountain") and the trail were objects of awe and held in great reverence by the Native American travelers.

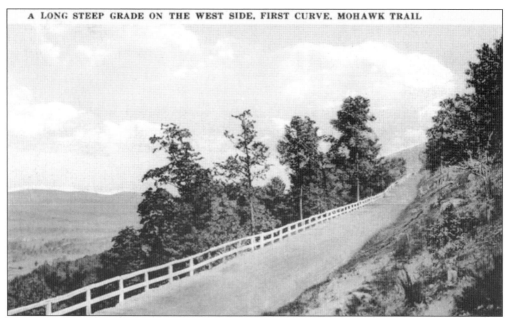

A LONG STEEP GRADE ON THE WEST SIDE, FIRST CURVE, MOHAWK TRAIL

The mountain pathway of the trail would eventually be transformed by the early settlers for passage of horses and wagons. The trail would act as a thoroughfare for the adventurous settlers of the area and the militia who would occupy Fort Massachusetts farther west on the trail. The modern Mohawk Trail shown in this postcard made the effort a little easier for the 20th-century traveler who took on the slope of Hoosac Mountain.

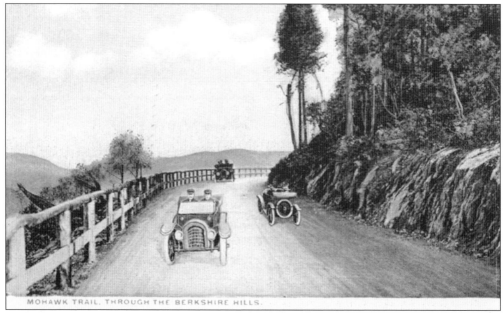

MOHAWK TRAIL, THROUGH THE BERKSHIRE HILLS.

This postcard gives the sense of height as the slope approaches one of the turns on the steep upgraded trail. It serves as a reminder as to how much this mountain range acted as a barrier that kept the Berkshires a wilderness for over 100 years subsequent to the settlement of the Massachusetts Bay Colony. Many felt the mountain barrier made the Berkshires more physically part of the state of New York while politically part of Massachusetts.

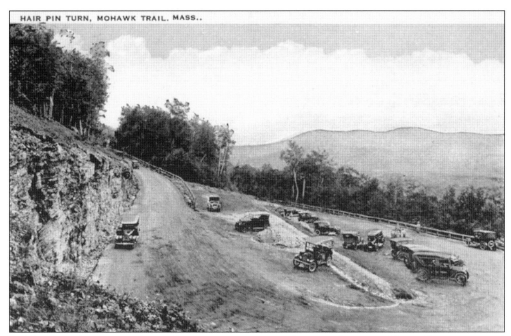

HAIR PIN TURN, MOHAWK TRAIL, MASS..

Halfway up the western slope of Hoosac Mountain is the most famous of the endless curves and turns on the trail. The Hairpin Turn is a human invention literally carved out of the rock of the mountainside. The next series of postcards reveals its growth and maturity from the rough cut, as seen here, to a commercial stop for tourists.

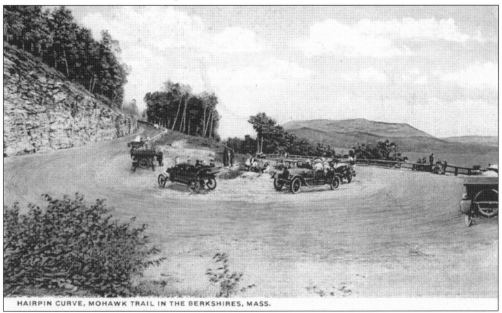

HAIRPIN CURVE, MOHAWK TRAIL IN THE BERKSHIRES, MASS.

This daring and thrilling idea of a turn is an excellent example of how the Mohawk Trail combines history, science, and the early American culture of industry and engineering all in one experience. The first Americans used their feet, acute instinct, and avenues of least resistance to accomplish their quest, while in contrast, the culture of industry applied brute force to the environment to reshape the trail's original course.

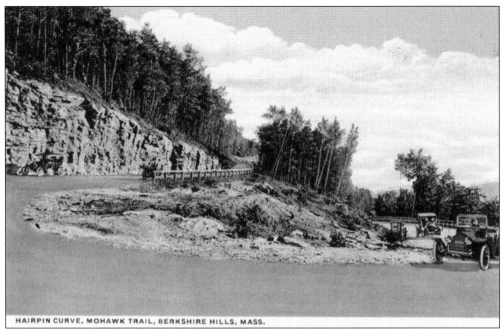

HAIRPIN CURVE, MOHAWK TRAIL, BERKSHIRE HILLS, MASS.

The Hairpin Turn was much more dangerous in its early years for automobiles, and many travelers preferred the old reliable horse and wagon or sleigh. By the 1920s, snowplowing of the trail began, and then a new surface aided the process to ensure a safer experience for the automobile.

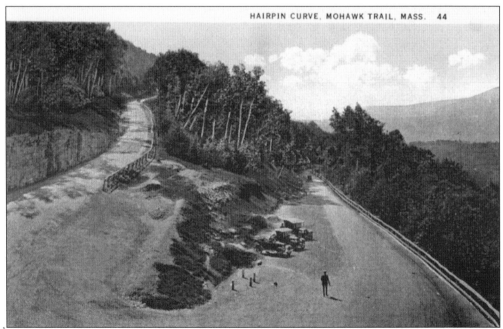

HAIRPIN CURVE, MOHAWK TRAIL, MASS. 44

As the trail and the Hairpin Turn became more polished, the thought of rougher times is enlightened through the writings of Nathaniel Hawthorne, who traveled the Mohawk Trail long before it became a modern highway. He felt its natural power as he wrote, "Often it would seem a wonder how our road was to continue, the mountain rose so abruptly on either side."

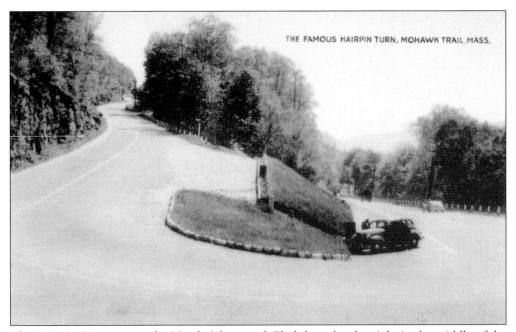

The Hairpin Turn crosses the North Adams and Clarksburg border right in the middle of the turn. So the traveler is in North Adams approaching the turn, in Clarksburg in the turn, and reenters North Adams after the turn.

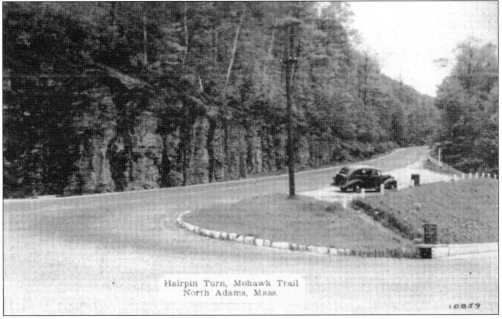

Hairpin Turn, Mohawk Trail
North Adams, Mass.

This postcard from the 1940s shows the Hairpin Turn as it looks today. The famous curve has had several other names, including Reverse Turn, Halfway Turn, the Loop, and Horseshoe Curve. But in the end, it symbolizes a new highway yet the oldest of paths through this part of the Berkshires.

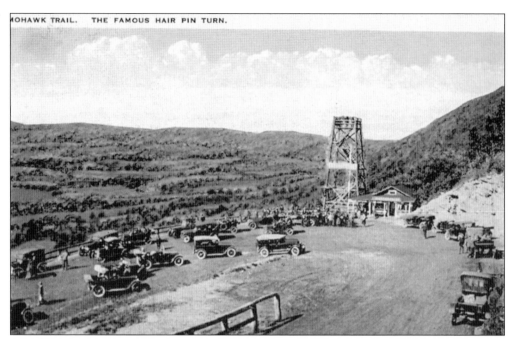

The head of the Hairpin Turn instantly grew in popularity, as did the trail, and thousands of people passed over the trail during the traveling season, spawning a multitude of stopping points along the way. The observation tower and gift shop gave tourists incentive to stop and enjoy the magnificent views of the Stamford Valley shown in the background of this postcard.

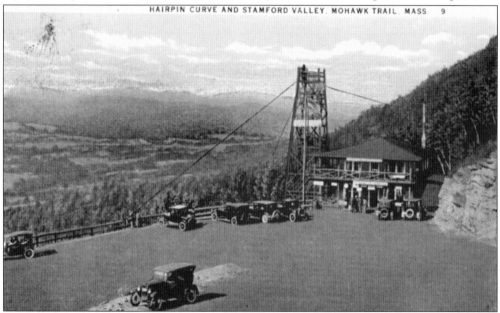

HAIRPIN CURVE AND STAMFORD VALLEY, MOHAWK TRAIL, MASS 9

This closer view of the tower and shop shows how close to the curving road at the head of the turn they were situated. Needless to say, this was vulnerable territory to the extreme and especially dangerous during the winter. The descending road on the right of the Hairpin Turn would be treacherous on an icy night. The shop and tower would have been a bull's-eye for any out-of-control vehicle.

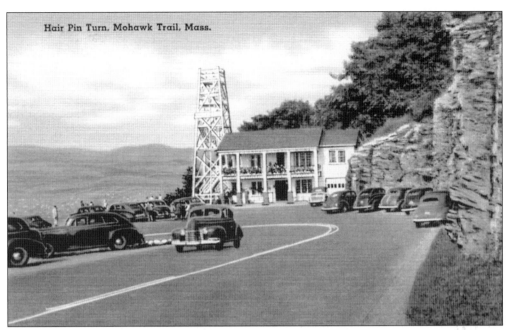

The tower remained but the shop changed in look in the 1930s. Once again, it is quite amazing to see where people parked their cars on the right side. The tail ends of the cars stick out into the curving road and into oncoming traffic, which comes down from a steep road from the top of the mountain.

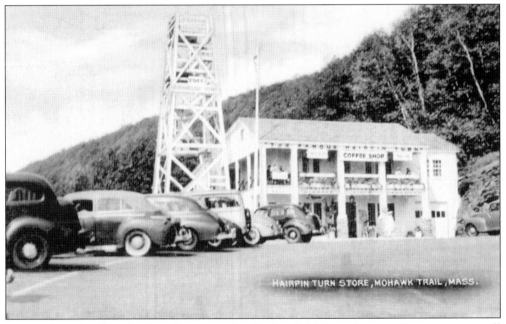

As seen from the sign, the shop is now serving food and drink, and eventually a restaurant will replace this coffee shop and the tower will be dismantled. The Golden Eagle Restaurant now occupies this space and is located in a less-vulnerable spot farther back from the head of the turn.

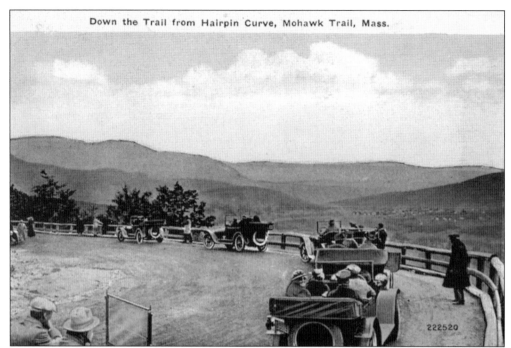

Down the Trail from Hairpin Curve, Mohawk Trail, Mass.

This postcard certainly demonstrates why people found this place irresistible. This view from the curve looks west toward the city of North Adams, lying peacefully in the valley below.

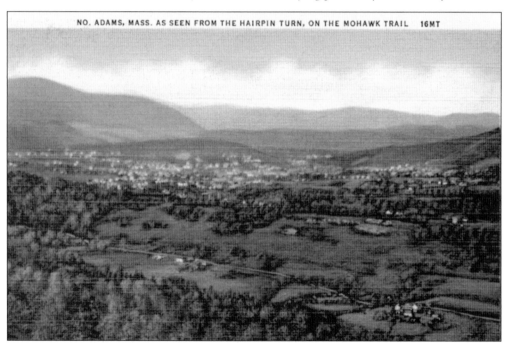

NO. ADAMS, MASS. AS SEEN FROM THE HAIRPIN TURN, ON THE MOHAWK TRAIL 16MT

This postcard shows a view toward the southwest revealing another panoramic scene of the Greylock mountain range and the valley with the city of North Adams below, and Williamstown would be about eight miles down the center of the valley. This view is another reminder of the distance covered by the ancient trodden pathway and by the feet of the first Americans.

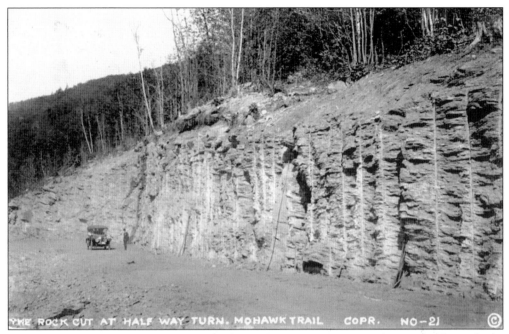

THE ROCK CUT AT HALF WAY TURN. MOHAWK TRAIL COPR. NO-21 ©

After the turn, the trail continues up the slope of Hoosac Mountain. This postcard reveals the engineering required to create the Hairpin Turn by carving out the mountainside. During the winter months, these carved walls change into natural ice sculptures as water from above drips downward and freezes into long hanging tentacles of crystal wonder.

The ice sculptures of winter show off on the walls of the Hairpin Turn. (Photograph by Robert Campanile.)

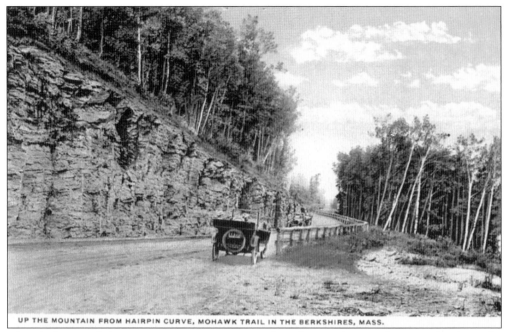

UP THE MOUNTAIN FROM HAIRPIN CURVE, MOHAWK TRAIL IN THE BERKSHIRES, MASS.

The challenge of the Hairpin Turn is conquered, and now the traveler must head up the mountainside. Whether coming or going, the ascent and descent involves several long inclines hewed out of the Hoosac's side, and with each curve comes a renewed sense of nature's beauty. (Courtesy of Justyna and Gene Carlson.)

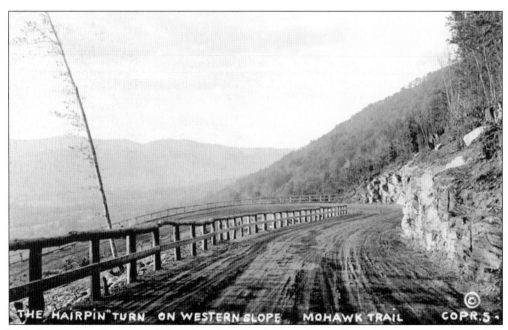

THE "HAIRPIN" TURN ON WESTERN SLOPE MOHAWK TRAIL COPR. 5.

This is a very early postcard showing the view before the road on the turn was paved. The image gives a clear sense of the descent into the curve from the sloping road.

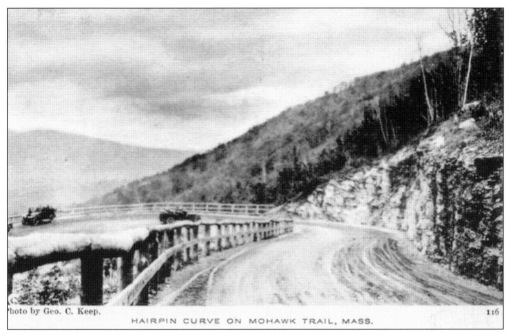

HAIRPIN CURVE ON MOHAWK TRAIL, MASS. 116

This same view as the previous postcard now introduces the winter ice and snow onto the scene. It now becomes obvious why this was no picnic during the winter months. It is difficult to imagine how the early automobiles could handle this type of terrain and conditions.

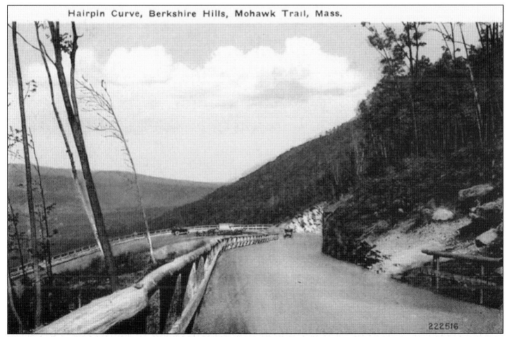

Hairpin Curve, Berkshire Hills, Mohawk Trail, Mass.

222516

This is a third view of the same perspective showing the descent from the slope into the Hairpin Turn. This scene is much more inviting and less intimidating during the softer and safer seasons of spring and summer.

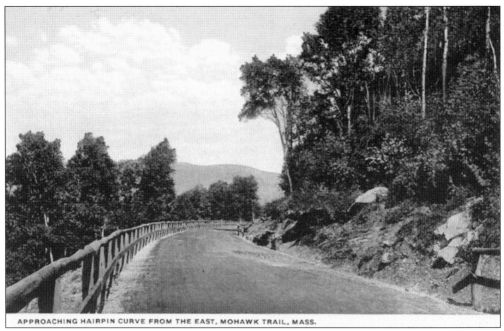

APPROACHING HAIRPIN CURVE FROM THE EAST, MOHAWK TRAIL, MASS.

This is the road farther up the slope as the top of the summit is being approached. It is still quite an incline and brings to mind historic visions of wagons laden with produce, supplies, and primitive products from both sides of the two valleys.

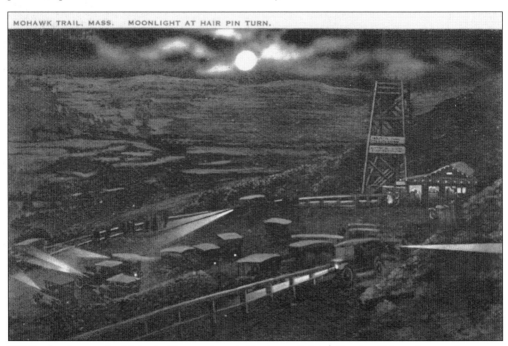

MOONLIGHT AT HAIR PIN TURN. MOHAWK TRAIL, MASS.

While the day on the Hairpin Turn paints the beauty of the valley in all its colors and texture, the night paints the beauty of the sky in all of its mystery. Moonlight at the turn conjures up feelings of romance, the mystical, and the heavenly magic and awe of the night sky as revealed from this mountainside throne.

Four

ON THE EDGE

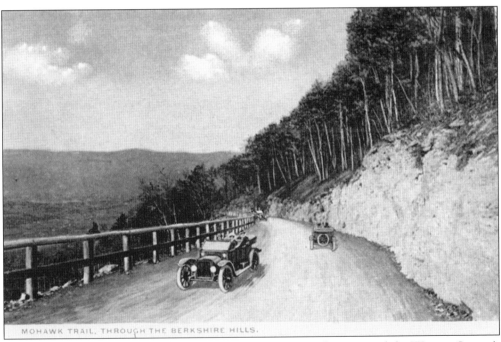

MOHAWK TRAIL, THROUGH THE BERKSHIRE HILLS.

Following the Hairpin Turn, the Mohawk Trail steeply crawls up toward the Western Summit of Hoosac Mountain. For centuries, the natives of the area trekked a footpath that ran through the Hoosac Valley, then up and over this mountain. It would continue into the Deerfield Valley, then to the Connecticut River and probably beyond. The settlers would eventually replace these ancient paths, and the final piece of the route was over the portion that crossed the great Hoosac barrier occurring sometime around 1753.

49

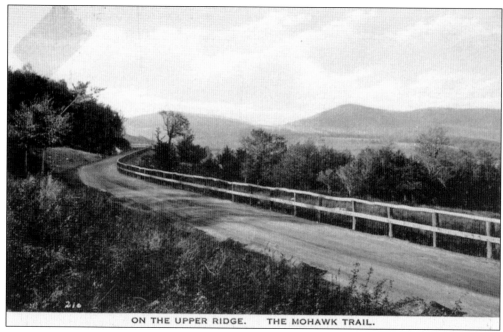

ON THE UPPER RIDGE. THE MOHAWK TRAIL.

The lifting and curving road that leads to the upper ridge of the mountain was not the original path used by the Native Americans. The path up the western slope walked by the natives most likely changed over time, evolving with the changing environment. This is probably true for all trails that were crossed on foot.

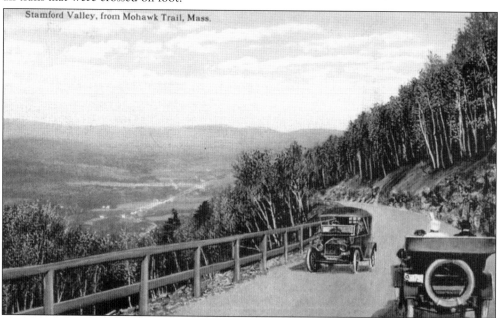

Stamford Valley, from Mohawk Trail, Mass.

While this part of the trail is certainly an engineering achievement seen in its straddling of the mountain slope, the natural engineering instincts of the early natives were just as sophisticated in their selection of their route, which surmounted many obstacles in their path. As the side-winding path gets closer to the summit, the traveler is subtly aware of the tall treetops whirring by suddenly at eye level. The air starts to chill and seems crisper.

50

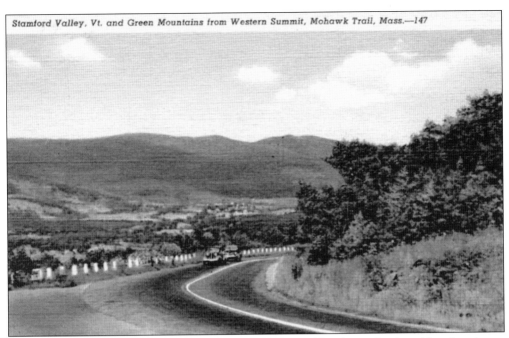

Stamford Valley, Vt. and Green Mountains from Western Summit, Mohawk Trail, Mass.—147

The trail abruptly levels off, and the traveler is welcomed by the projecting ridge that sits on the edge of the Western Summit of Hoosac Mountain (just off to the left of the road in this postcard). The Mohawk Trail will continue on around the curve and resume its journey east.

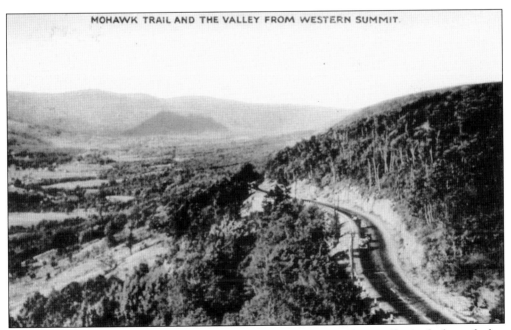

MOHAWK TRAIL AND THE VALLEY FROM WESTERN SUMMIT

Once perched on Western Summit, looking back down, the winding trail reveals the path that led to this destination. The trail, the valley, and the lengthy climb by automobile are all seen from this vantage point and make the idea of a footpath even more mind-boggling.

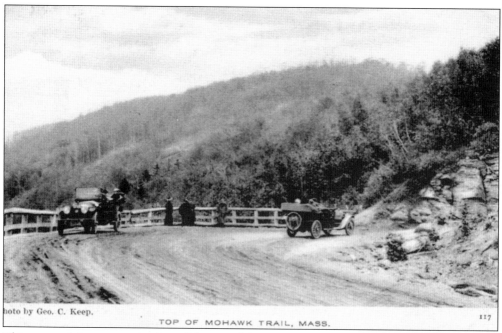

TOP OF MOHAWK TRAIL, MASS. 117

This postcard shows an early view of the top of the mountain before it was developed for tourists.

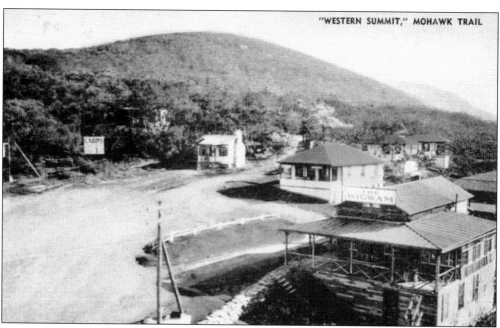

"WESTERN SUMMIT," MOHAWK TRAIL

Eventually a large gift shop and motel crowned Western Summit. The Wigwam began in 1914 when the modern Mohawk Trail opened. It was a complex of cabins and a gift shop. In the center at the bottom of the card just left of the gift shop is the stone wall where a visitor would stand to get the wondrous panoramic view of the valley floor below.

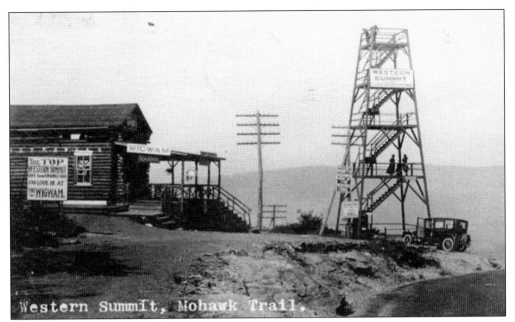

The Wigwam also erected a popular observation tower for more intense dramatic views. This postcard shows the tower in 1914.

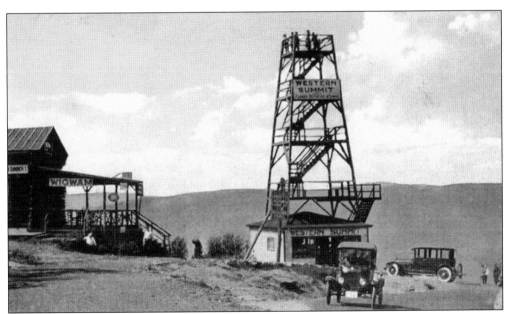

Another view of the tower shows an added structure next to it. It is believed that Nathaniel Hawthorne, at an earlier time, stopped at this area and the view inspired him to write, "The village [North Adams] viewed from the top of a hill to the westward, at sunset, has a peculiarly happy and peaceful look . . . and seems as if it lay in the hollow of a large hand."

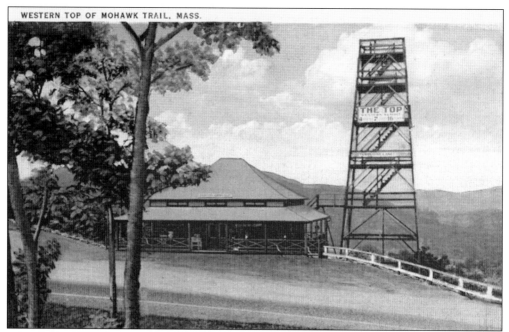

It has always been debated where the best view exists on the Mohawk Trail. There is no doubt the western edge of the trail provides an incomparable view. But the rest of the journey will certainly provide legitimate competition.

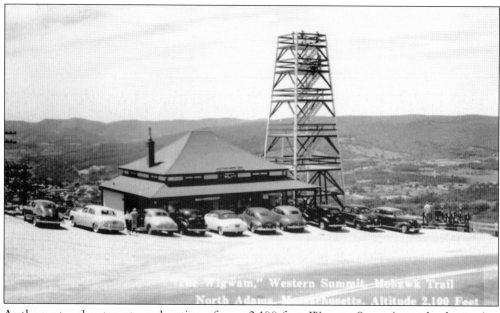

As the postcard notes, at an elevation of over 2,100 feet, Western Summit can lend meaning to the word panoramic. The following postcard views will attest to that. Western Summit is also, although rarely, referred to as "Perry's Peak" in honor of Prof. Arthur Perry of Williams College, who named many of the places in sight of this spot and was the historian on Fort Massachusetts.

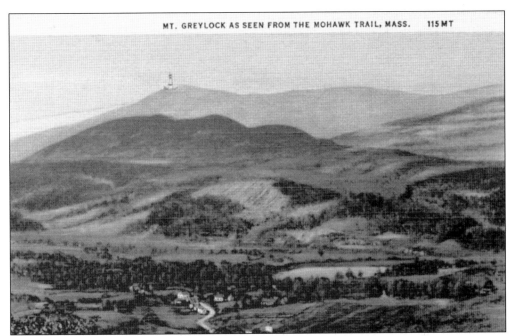

Standing on the crest of Western Summit, a view of the mighty Greylock Mountain to the west dominates the background. Greylock is the tallest peak in the state at over 3,300 feet. The memorial beacon is seen topping the mountain at its highest point. The pattern of the rich valley floor completes the breathtaking view.

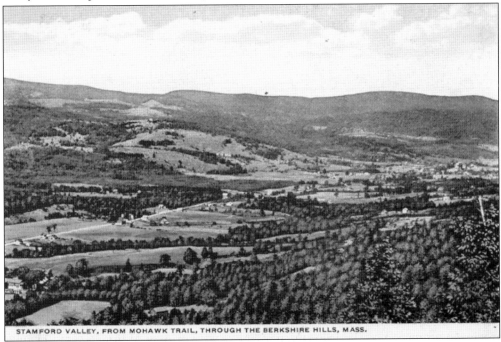

STAMFORD VALLEY, FROM MOHAWK TRAIL, THROUGH THE BERKSHIRE HILLS, MASS.

A slight turn of the head to the right reveals the northern Green Mountains of Vermont and the Stamford Valley with its fertile land, ribbons of roads, and miniature landscapes stretching to the northern horizon.

VIEW OF NORTH ADAMS FROM WEST VIEW GIFT SHOP, MOHAWK TRAIL, MASS.

80

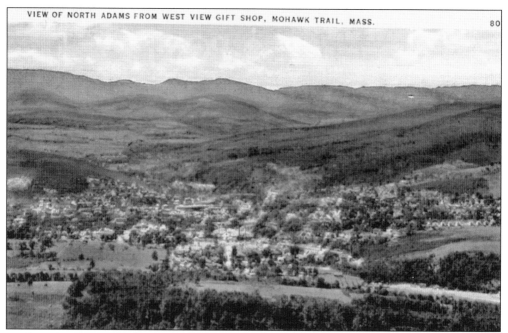

Looking directly west from Western Summit has the city of North Adams taking center stage. With excellent eyesight, a view of steeples, spires, tall chimneys, and the westward Mohawk Trail can be seen. Beyond sight, clenched between the valley's distant grasp, is the gem of the northern Berkshires from whence the journey began—Williamstown.

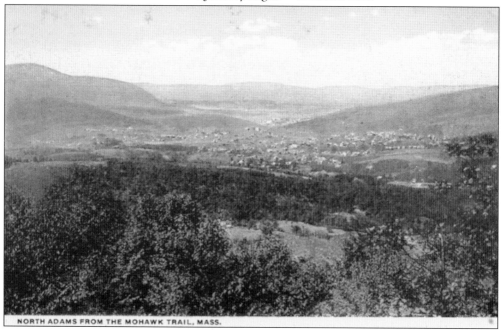

NORTH ADAMS FROM THE MOHAWK TRAIL, MASS.

From Western Summit, it becomes apparent that the old trail transverses parts of three states—Vermont, New York, and Massachusetts. It mapped the walkway of the Five Nations of the Iroquois Federation and is now named after the Mohawks, considered to be the strongest of that federation. It is one of the oldest byways on the continent.

Five

OVER THE MOUNTAIN AND THROUGH THE WOODS

The odyssey from Western Summit to the outskirts of Greenfield is often referred to as the "Scenic Mohawk Trail." The postcard images in this chapter will certainly legitimize that title. Leaving Western Summit behind, the trail will slowly start to drop into a valley on top of the mountain. The sense of being in a valley up this high, however, will be lost entirely. The first town encountered in this enchanted valley is Florida.

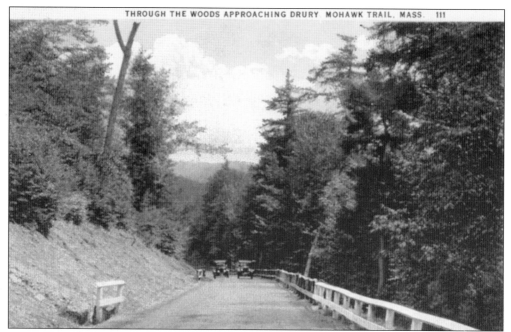

The town of Florida was settled in 1783 by hardy trail travelers who decided the cold winters on top of a mountain were bearable. The town was incorporated in 1805 and was the scene of a good part of the building of the famous Hoosac Tunnel from 1851 to 1875. This postcard shows the absolute beauty of the trail on this side of the western ridge near a section called Drury.

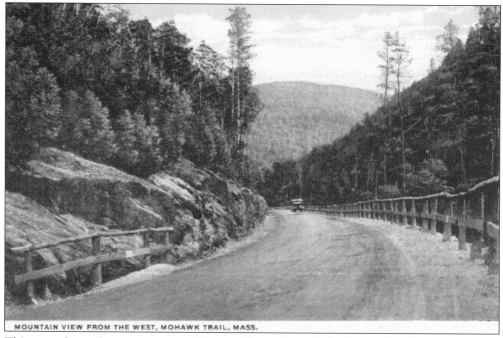

MOUNTAIN VIEW FROM THE WEST, MOHAWK TRAIL, MASS.

This scene shows the western crest of Hoosac Mountain in the background as the trail continues through the valley surrounded by tall pines.

One thing that the trail has in abundance is curves. Some have become legendary. Traveling east through Florida as the town of Charlemont approaches are two such curves. One is referred to as "Deadman's Curve."

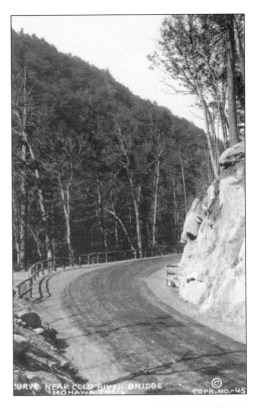

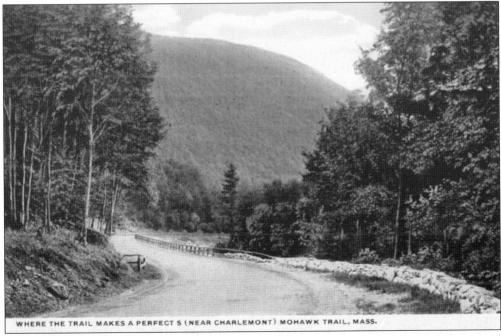

WHERE THE TRAIL MAKES A PERFECT S (NEAR CHARLEMONT) MOHAWK TRAIL, MASS.

The curves, sometimes seemingly out of nowhere, contribute to the fluid poetry of motion and certainly never allow boredom to enter the traveling experience. The postcard scene occurs just before encountering the perfect S, or as most call it, "the curve of beauty."

59

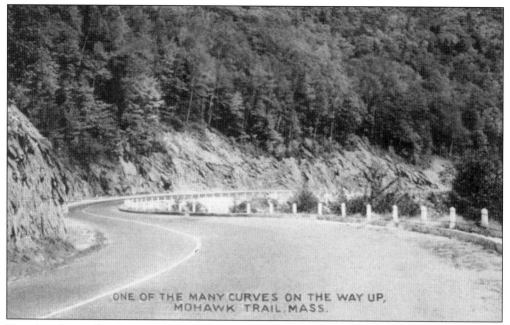

Entering the perfect S means being met on the left by a fast-approaching mountain wall and on the right by a deep drop ravine. Of course, there is also the oncoming traffic in the close opposite lane to keep an eye on, if the scenery and the motion of the curve have not totally taken over.

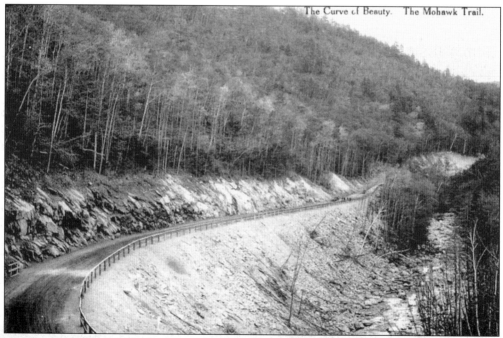

This postcard shows the deep ravine coming out of the curve of beauty before the road had a center line and was widened. Remember this is a two-way lane. The river below on the right is the Cold River.

The serpentine curve of beauty, shown here as approached from the east, slithers toward the towering mountain range to the west. This has to be appreciated at night when the walls of the mountain create a deep abyss of darkness on all sides with a perfect S curve appearing in the headlights with no warning.

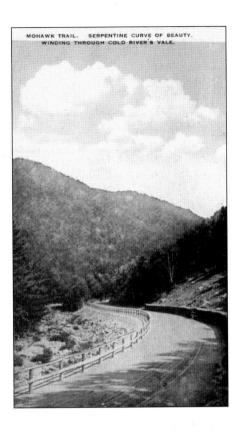

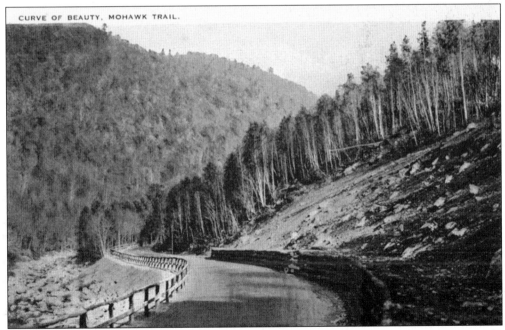

A wider view of the curve from the eastern direction gives an indication of the steep mountain slope and forests on the right side and the deep drop into the river ravine to the left.

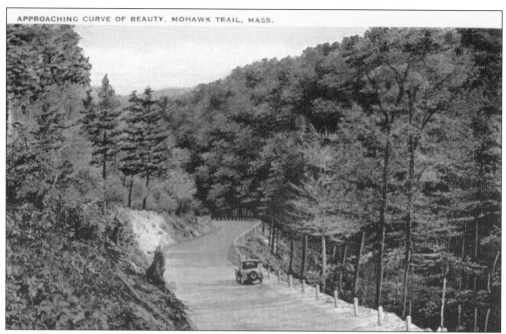
APPROACHING CURVE OF BEAUTY, MOHAWK TRAIL, MASS.

This portion of the Mohawk Trail creates a duel contradictory feeling. In one sense, the cradling of the mountain ridges produces a cozy, secure setting, yet the gurgles of water flowing from the deep ravine waken the sense of vulnerability.

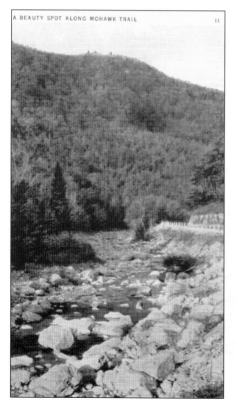
A BEAUTY SPOT ALONG MOHAWK TRAIL II

Beauty abounds on the trail, although at the same time it is said that the early settlers of this region described the area as "the appalling loneliness of the wilderness."

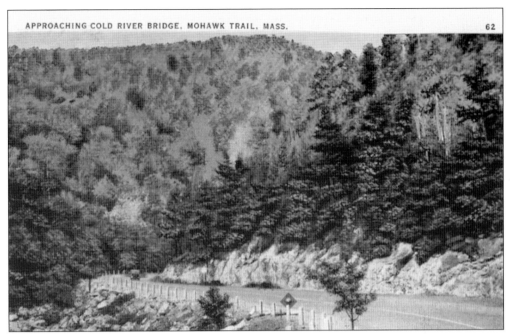

The Mohawk Trail, like most of the original footpaths, follows the river. With the Cold River as a constant companion, the trail takes on other dimensions of beauty as expressed again by Nathaniel Hawthorne: "Between the mountains there are gorges that led the imagination away into new scenes of wilderness."

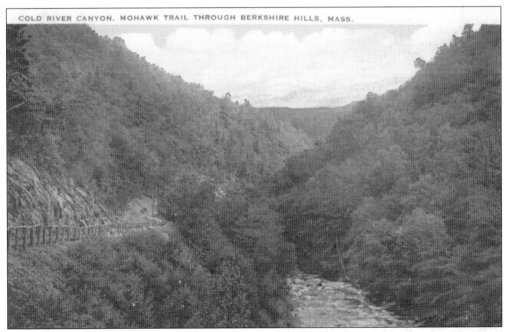

COLD RIVER CANYON, MOHAWK TRAIL THROUGH BERKSHIRE HILLS, MASS.

Here the modern Mohawk Trail seems to follow closely the old native trail as the natives would have straddled the riverbanks. This postcard depicts another gorgeous canyon carved out by the river.

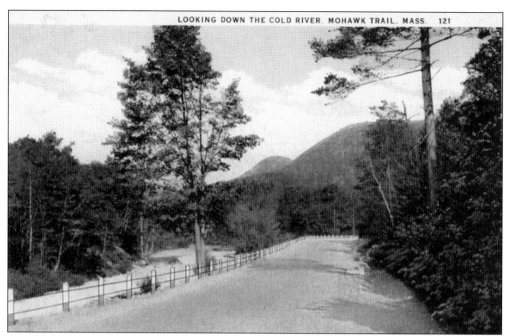

LOOKING DOWN THE COLD RIVER, MOHAWK TRAIL, MASS. 121

For the tourist approaching this area from either direction, there is a constant encounter of rapidly changing scenery that creates a tone of past epochs and a sense of nature's grand scheme.

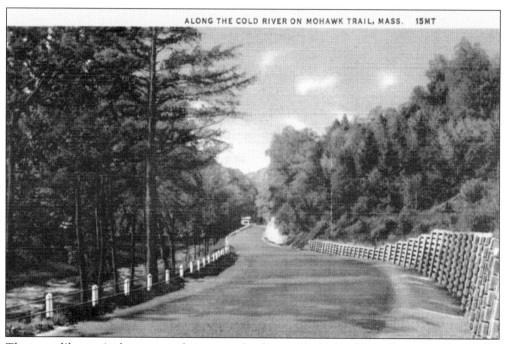

ALONG THE COLD RIVER ON MOHAWK TRAIL, MASS. 15MT

The trees, like sentinels, contrast their strength of age with the fragility of young saplings. The fullness of the foliage cushions the traveler from the rest of the world, and the sound of the Cold River plays soothing melodies on the rocks.

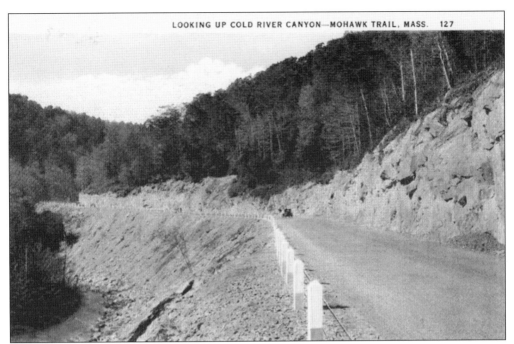

The Cold River canyon struts rugged and massive rock walls that protrude with primitive outlines against the backdrop of the more sensitive pine and deciduous forests.

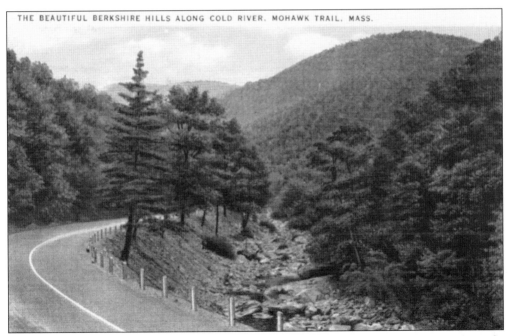

THE BEAUTIFUL BERKSHIRE HILLS ALONG COLD RIVER, MOHAWK TRAIL, MASS.

This mesmerizing ride along the banks of the Cold River is enhanced by rising mountain peaks that dash from side to side as the twisting trail cannot seem to make up its mind as to which direction to go.

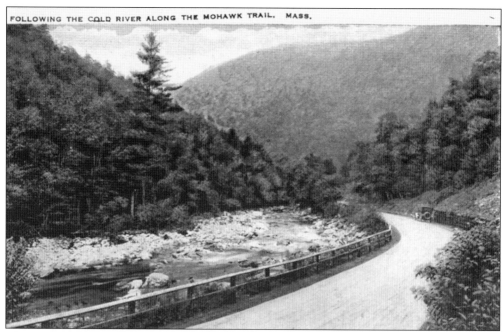

The narrow confines of the valley floor seem to push the river and trail into a natural marriage. The natural and the human-made go side by side as if nature always intended it to be this way.

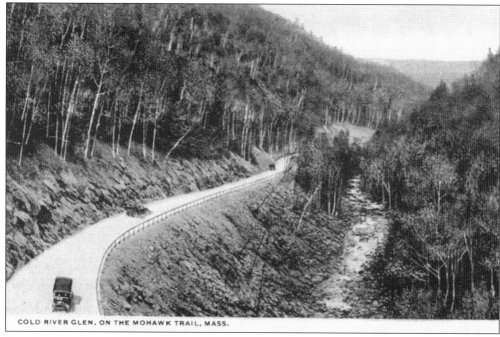

COLD RIVER GLEN, ON THE MOHAWK TRAIL, MASS.

Someone once said that while the modern Mohawk Trail may be traveled by the automobile, drivers still had to travel the trail "Indian style" in single file.

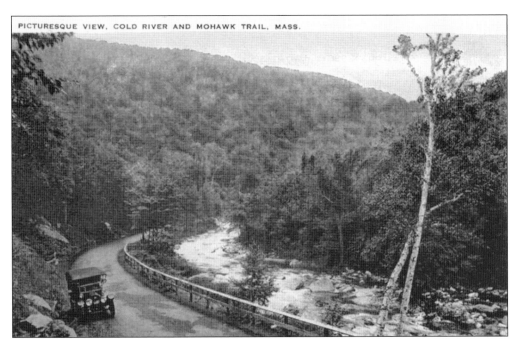

PICTURESQUE VIEW, COLD RIVER AND MOHAWK TRAIL, MASS.

The traveler experiences a deep ravine below with ascending peaks above the road that is a mere wide shelf chiseled out of the natural rock. This Cold River glen is a particularly gentle thrill with subtle curves. Today most of the deep ravine is hidden by the tree growth on the banks.

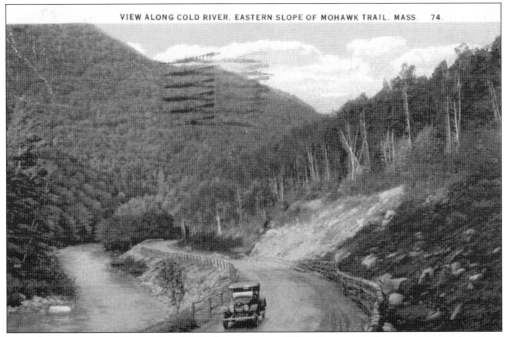

VIEW ALONG COLD RIVER, EASTERN SLOPE OF MOHAWK TRAIL, MASS. 74.

Very few sections of the Mohawk Trail are more wild and natural than that along the steep heights overlooking the Cold River. In the narrow valley of the Cold River, once again Nathaniel Hawthorne is inspired: "I have never ridden through such romantic scenery."

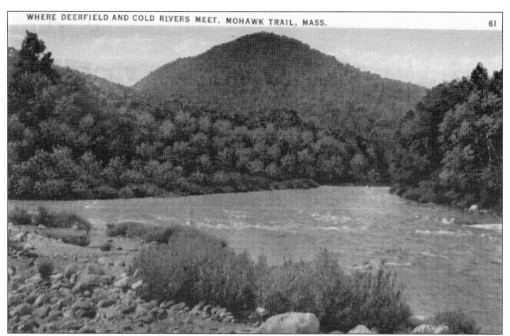

As the Mohawk Trail and the Cold River stretch across the town line of Charlemont, the river finally yields to a merger. From the north, the Deerfield River dissolves the waters of the Cold River and its marriage to the trail into one unified flow. This merging of waters is believed to have once been a historic and significant campground of the Native Americans.

The waters of the Deerfield River now become the trail's new spouse and command the trail's destination to the east. The sinuous trail seems to follow the original footpaths quite closely in this area and was clearly defined as a path by the time the initial settlers from Deerfield crossed it in the 1700s.

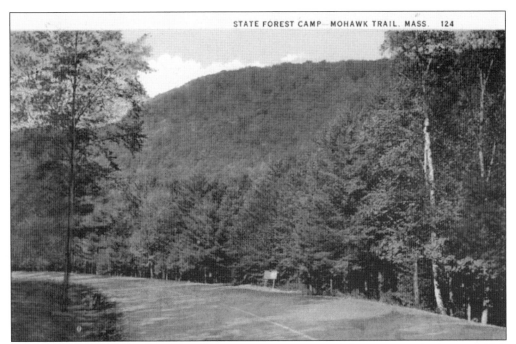

The Mohawk Trail State Forest surrounds a large section of the road in Charlemont. This postcard shows an entrance into the beautiful state reserve.

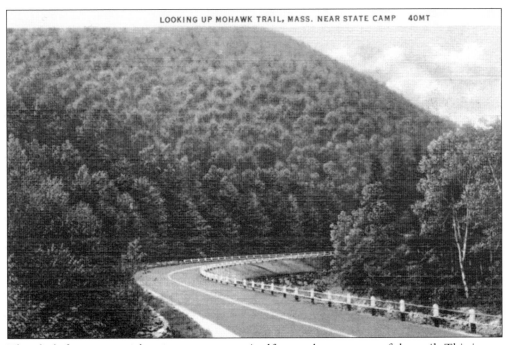

The plush forestry near the state camp wraps itself around every turn of the trail. This is one of those special sections on the trail. The sense of nature is always within reach and permeates every moment.

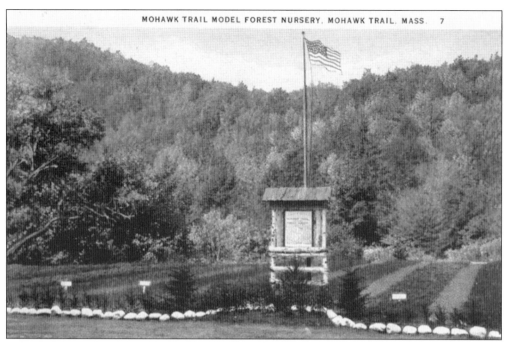

A forest nursery was once located on the trail to complement the ageless beauty of the forested hills that surrounded it.

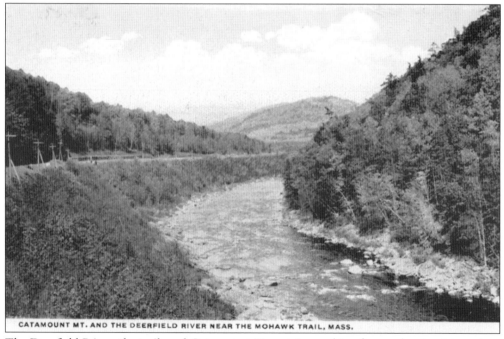

CATAMOUNT MT. AND THE DEERFIELD RIVER NEAR THE MOHAWK TRAIL, MASS.

The Deerfield River, the trail, and Catamount Mountain combine for another inspiring view. This scene's rural setting brings to the imagination a time in the past when the trail was essentially a footpath for hunting, communication, scouting, and general movement. This postcard has the mind almost seeing the people of ancient times crossing through the environment.

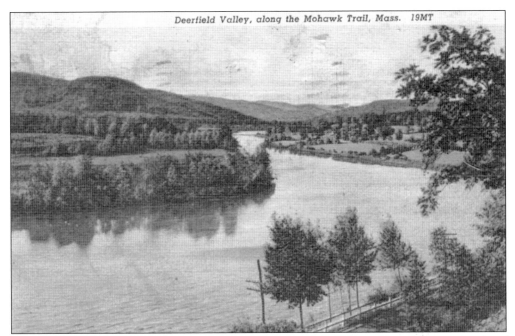

The Pocumtuck Indians of the Deerfield River valley had been friendly with the Mohawks of New York until 1663 when they decided to ally themselves with the Mahicans and Wappingers of the Hudson River. This would have grave consequences for their future with the Mohawks. It is hard to visualize hostilities with such a peaceful scene as in this postcard.

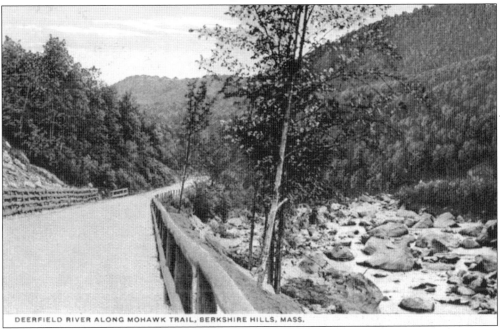

Sahada, a Mohawk chief, was sent over the old trail to bear gifts to the Pocumtucks and solidify a treaty. The Pocumtucks murdered the Mohawk ambassador, and to avenge Sahada's death, the Mohawks marched via the trail with a powerful force of warriors. They triumphed over the Pocumtucks and some say earned their right to bear the trail's name.

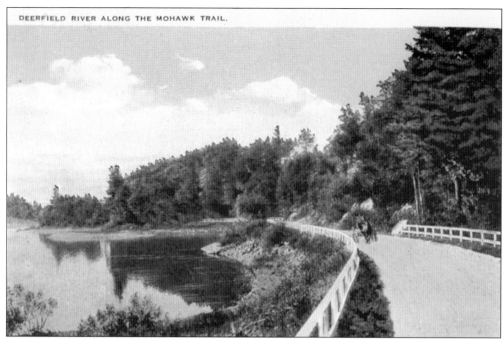

DEERFIELD RIVER ALONG THE MOHAWK TRAIL.

The reflective beauty, both figuratively and literally, of the Deerfield River is demonstrated in this postcard view.

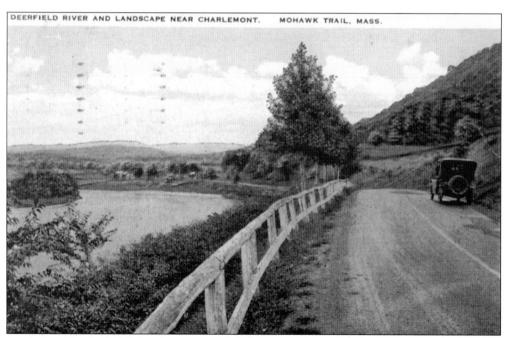

DEERFIELD RIVER AND LANDSCAPE NEAR CHARLEMONT. MOHAWK TRAIL, MASS.

Sections of the Mohawk Trail in Charlemont open up, and the closeness and restriction of the woods is replaced by the serenity and vastness of the meadows. Even the air seems to react to the freedom of movement generated by the open environment.

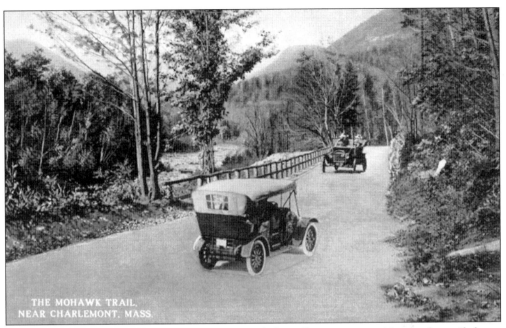

The moving trail imitates the moving river, and the valley starts to widen as the trail draws closer to the center of Charlemont.

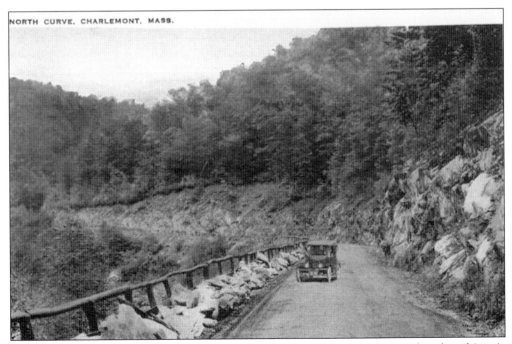

The north curve near the village of Charlemont leads to the settlement with a deep historic past on the trail.

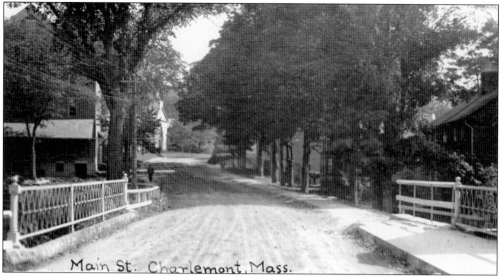

Main St. Charlemont, Mass.

The quaint and picturesque Main Street of Charlemont instantly takes the traveler back in time. Settled in 1742 and incorporated in 1765, this village, midway on the trail, has a fascinating history.

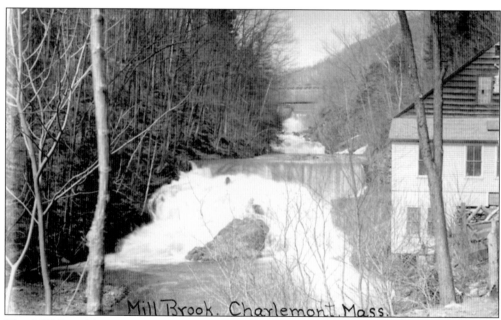

Mill Brook. Charlemont. Mass.

The Mill Brook's waters were no doubt flowing when Moses Rice decided to be the first settler to build his home on the Mohawk Trail in Charlemont in 1743. The natives of the area burned his home down, but he rebuilt and inspired others to follow. His son Sylvanus fought in the American Revolution and led the townspeople over the trail to assist in the Battle of Bennington.

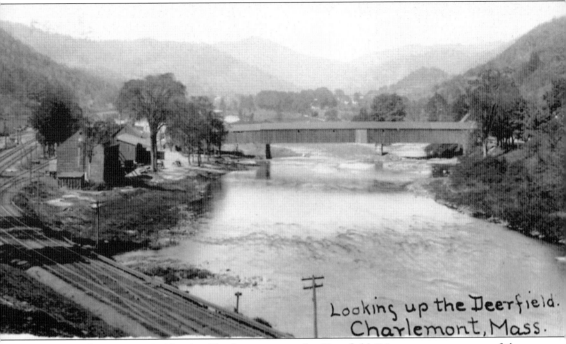

Looking up the Deerfield. Charlemont, Mass.

The magnificent Long Bridge in Charlemont over the Deerfield River was a remnant of the glory days of the covered bridge in New England. It was 324 feet long and until 1944 was a favorite destination for sightseers and artists traveling the trail.

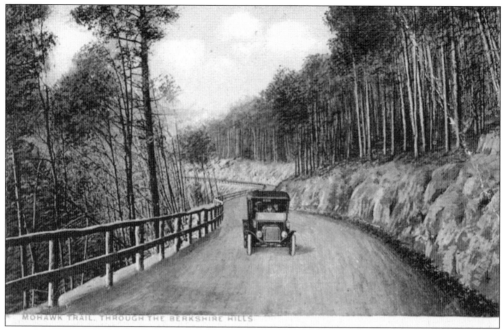

In 1786, interested parties organized to create a decent wagon road over Hoosac Mountain from Charlemont. This was the Stage Road, and it had a long history of use.

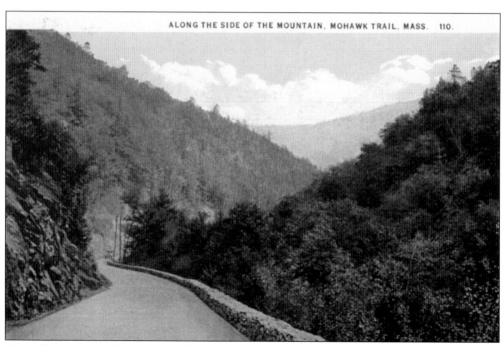

An earlier road was the Rice Road (named after Samuel Rice of Charlemont who petitioned it). It was rough but connected the east and west side of Hoosac Mountain. It was referred to as the "Shunpike" because people used it to avoid a toll road. A trail marker still exists with that title.

MOHAWK TRAIL

These two postcards are a good example of the trail before and after reconstruction, which took place initially in 1927, then with further improvements during the 1940s, 1950s, and 1960s. These included widening the trail and paving for easier maintenance, especially during the winter months.

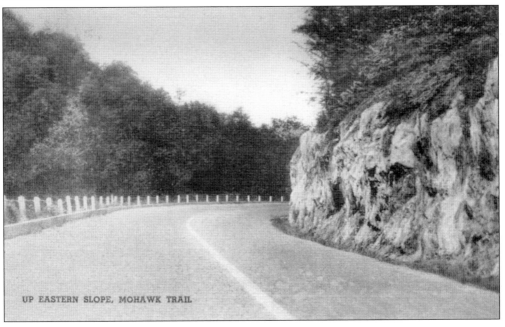

UP EASTERN SLOPE, MOHAWK TRAIL

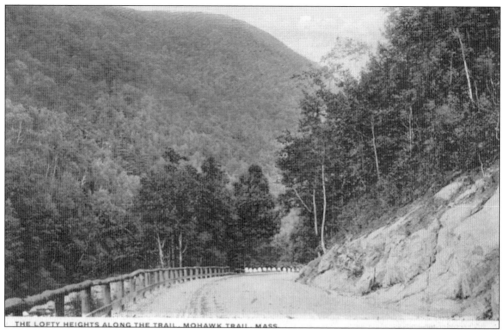

THE LOFTY HEIGHTS ALONG THE TRAIL, MOHAWK TRAIL, MASS.

The trail was the path that the men of Charlemont and neighboring villages of the Deerfield Valley crossed to answer the call to arms from the other side of Hoosac Mountain. They rallied on this path to Williamstown to check the approach of the Hessians at the Battle of Bennington.

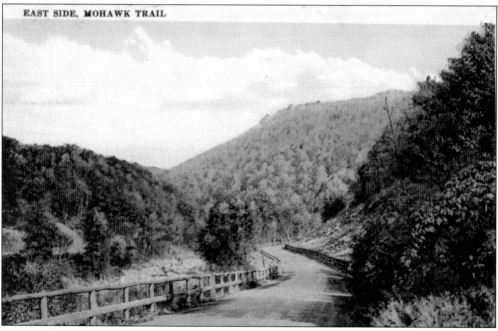

EAST SIDE, MOHAWK TRAIL

During the 19th century, the trail was a symbol of the western expansion taking place in America. Pioneer wagons cut into the trail, to be shortly followed by regular stagecoach travel. Only the construction of the Hoosac Tunnel through the mountain in 1875 would slow the use of the trail as the railroad took preference.

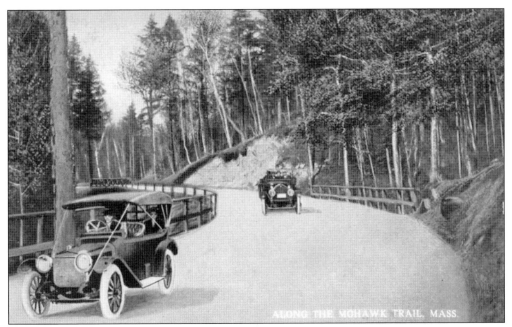

No one really knows how far back the history of the original trail goes. Before 1590, very little is known about the footpaths created by the Native Americans. Until the mid-1700s, there is no definite account of any particular significant event on the trail.

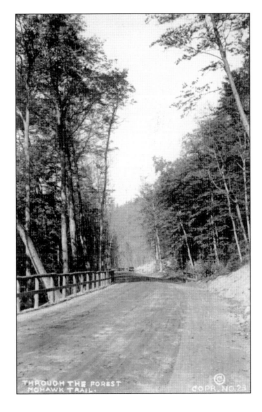

The Mohawk Trail has endured as an ancient footpath and as a major modern automobile highway. Whatever humans decide for its use in the future, nature will always supply the much-needed inspiration on this historic path.

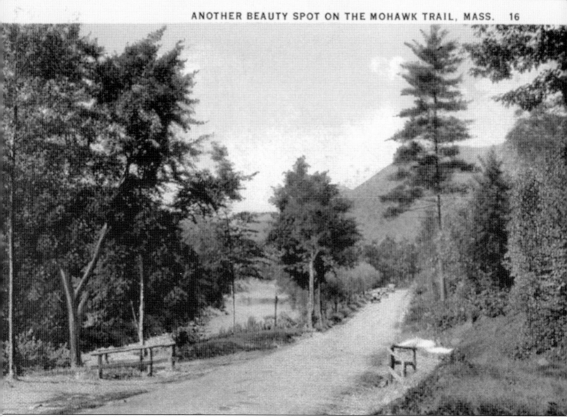

While the modern Mohawk Trail is generally considered to connect Williamstown on the west end with Greenfield on the east end, there is technically no limit to its ancient eastern and western extremes.

Six

SUMMIT MEETINGS

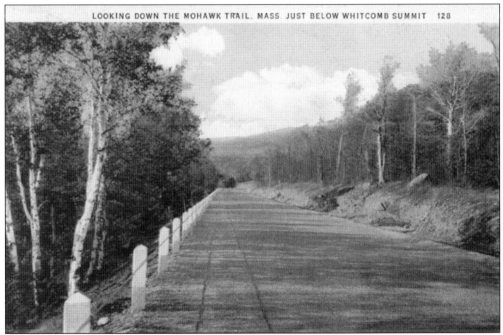

LOOKING DOWN THE MOHAWK TRAIL, MASS. JUST BELOW WHITCOMB SUMMIT 128

Where there are mountains, there are peaks. Where there are peaks, there are summits. The Mohawk Trail, with its multitude of peaks and valleys, has a great selection of majestic and enticing summits for the adventurous traveler to enjoy. Starting from the previously discussed Western Summit (see chapter 4), the trail heads east down a valley and eventually elevates again at the east side of the Hoosac range. This postcard shows the trail approaching the next major summit, called Whitcomb Summit.

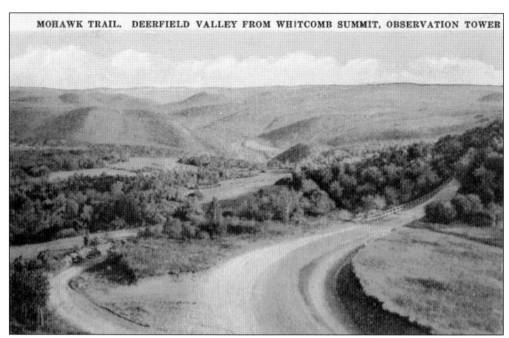

The next four postcard images display the progression through the years of Whitcomb Summit. This first image shows the summit before the extensive development. The magnificent view beyond the trail of the distant mountains demonstrates why it was a favorite spot for trail travelers.

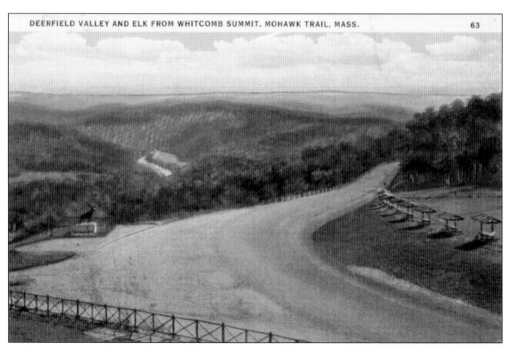

DEERFIELD VALLEY AND ELK FROM WHITCOMB SUMMIT, MOHAWK TRAIL, MASS. 63

This second image has the famous elk monument enclosed by a fence on the left side of the trail on the turn (for more on *The Elk*, see chapter 8). Picnic tables with shade covers dot the right side of the trail.

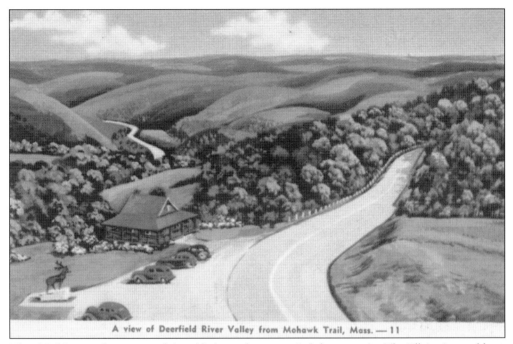

A view of Deerfield River Valley from Mohawk Trail, Mass. — 11

The third image shows one of the gift shops that occupied the summit. *The Elk* is pictured here without the enclosed fence on the bottom left.

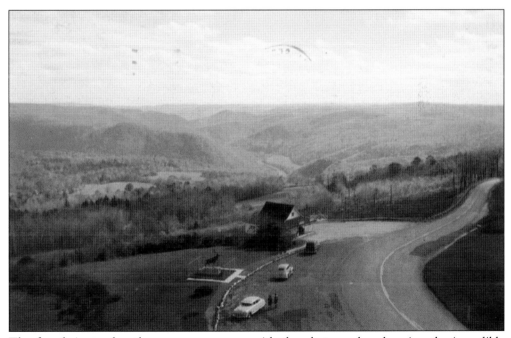

The fourth image has the same appearance with the photograph enhancing the incredible scenic view beyond the summit. The rental cottages would be to the far right beyond the postcard border.

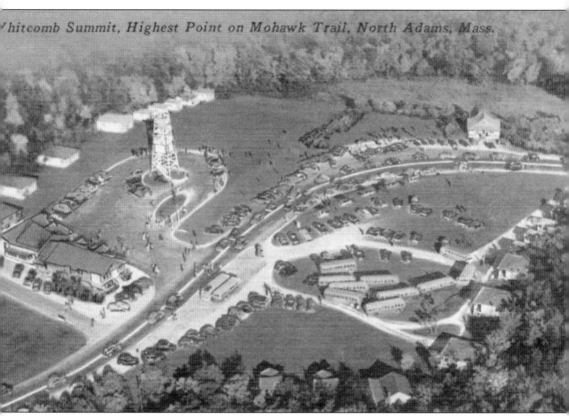

This aerial view of Whitcomb Summit gives an excellent idea of how popular it was when the trail was a major tourist destination. This is probably around the 1930s and 1940s, showing numerous automobiles and buses from the immense interest as a stopping point on the trail. The gift shop is pictured on the left side with the famous observation tower just above it and to the right. Lining the bottom right corner of the postcard from bottom to top are the rental cottages on the other side of the road.

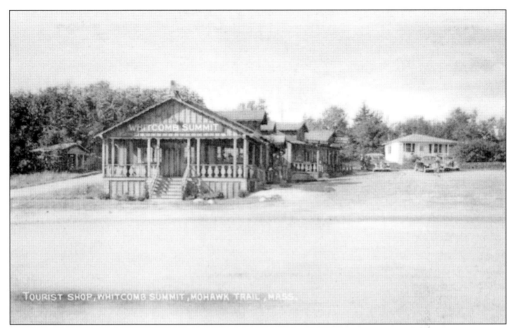

Whitcomb Summit is located in the town of Florida and has the distinction of being the highest point on the Mohawk Trail at 2,173 feet. The summit began its popularity as a commercial stop in 1915, a year after the modern trail had opened. The roadside shop and observation tower instantly attracted a multitude of people.

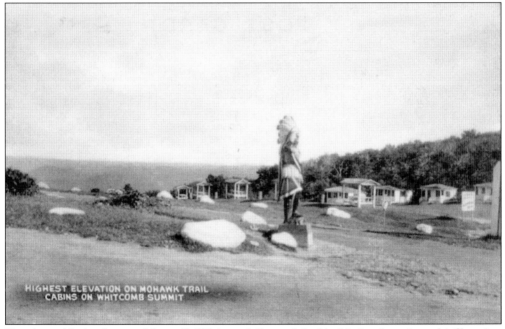

Keeping with the theme of the trail, Whitcomb Summit had its Native American chief keeping an eye on things and tempting travelers to stop and enjoy the natural view and, of course, spend some money. This statue would be one of many on the trail to keep the connection with its ancestral originators.

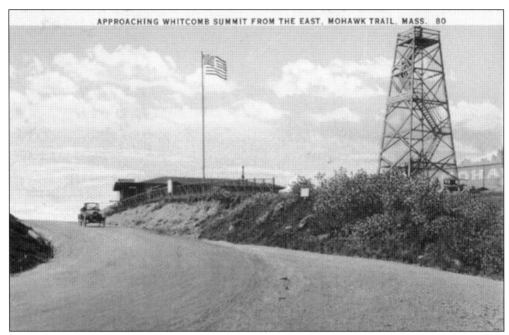

Whitcomb Summit is, of course, noted foremost for its views and can provide a variety of them on a clear day. The selection included parts of Massachusetts, Vermont, New York, and New Hampshire from the top of the tower pictured in this postcard. The views today are limited because the tower is now only half the height.

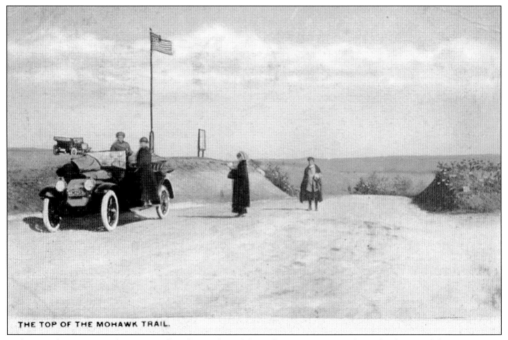

THE TOP OF THE MOHAWK TRAIL.

Whitcomb Summit diverges a bit from the old trails to accommodate the beautiful views. It is hard to believe that the Native Americans would have not done the same.

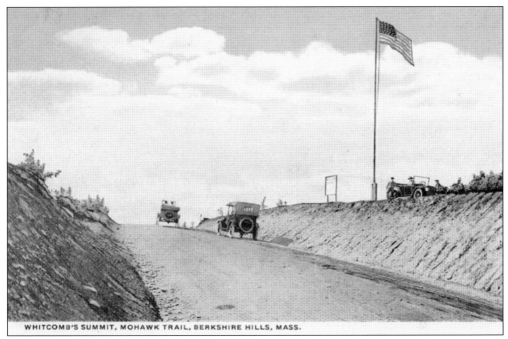

WHITCOMB'S SUMMIT, MOHAWK TRAIL, BERKSHIRE HILLS, MASS.

In the days of the Stage Road, it was said that a stop was always made at Whitcomb Summit so that the occupants could rest and rejuvenate themselves from the rough-and-tumble ride. The views from here certainly would have been an effective, refreshing tonic.

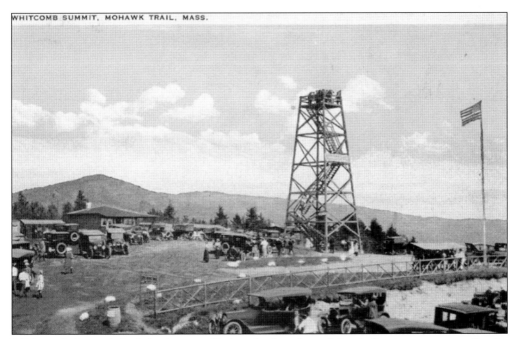

WHITCOMB SUMMIT, MOHAWK TRAIL, MASS.

Whitcomb Summit had the honor of being the location of the dedication ceremony for the opening of the modern Mohawk Trail on October 22, 1914.

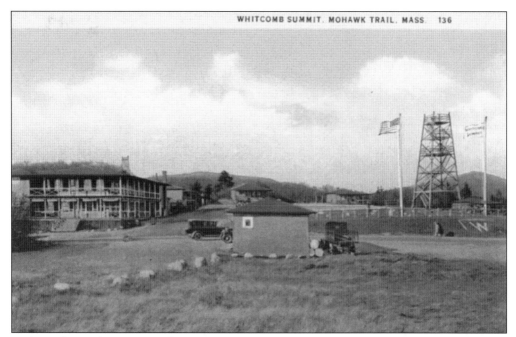

Today Whitcomb Summit still operates during the tourist season. The wooden tower is still there but only half the size. But the views and the euphoric feeling they provide still remain as long as the grass grows and the water flows.

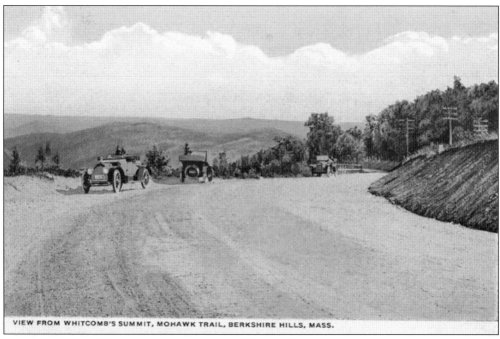

VIEW FROM WHITCOMB'S SUMMIT, MOHAWK TRAIL, BERKSHIRE HILLS, MASS.

In 1870, Rev. Washington Gladden stopped at Whitcomb Summit in his travels over the trail and wrote, "Every artist whether in words, or colors ought to look upon this landscape. It would teach him a useful lesson."

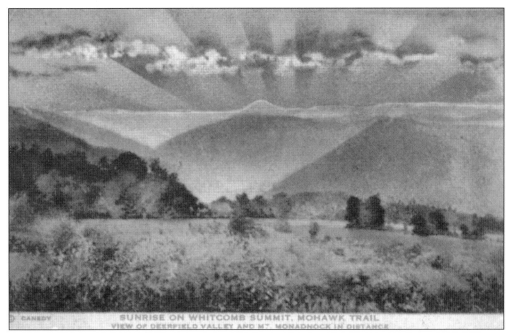

To quote the back of this postcard, "A scene of beauty and splendor greets the eyes at sunrise on Whitcomb Summit. In the moment before dawn, gloomy shadows fill the valley, then comes the lighting of the sky, numerous beams of light gleam forth from behind distant mountain ranges, and in a few minutes chase the shadows and fill the valley with sunshine."

Leaving Whitcomb Summit, the trail descends just a bit and reunites with the forests. Not too far down the path lies another summit and its claim to fame.

A few more tenuous curves and the crest of the eastern range of Hoosac Mountain will provide more memorable views and a piece of history on the Mohawk Trail.

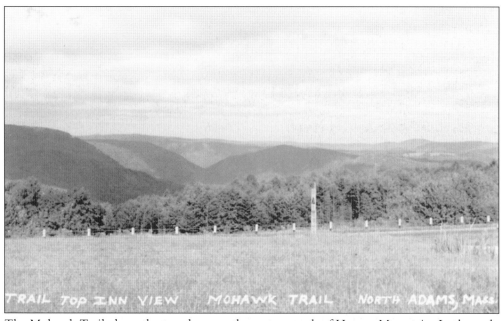

The Mohawk Trail places the traveler over the eastern peak of Hoosac Mountain. In the early days of the modern trail, the Trail Top Inn crowned what is now referred to as Eastern Summit. As this postcard attests to, the view is spectacular.

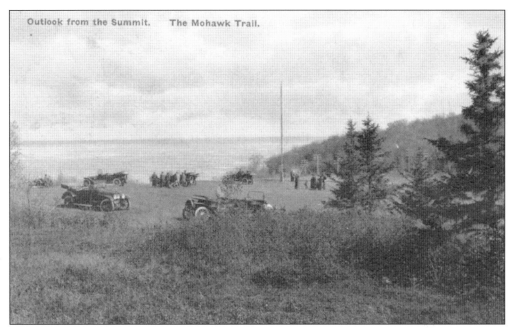

Outlook from the Summit. The Mohawk Trail.

The Mohawk Trail carries the traveler to a panoramic plateau and to the top of the eastern range from which an open view of the valley is secured. This area would become known as the Outlook.

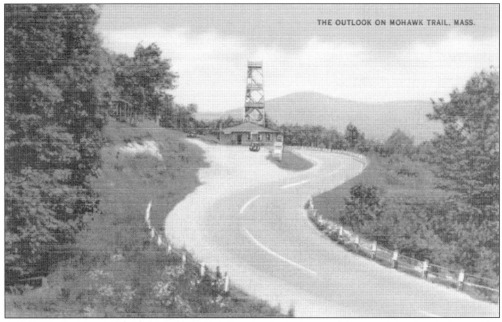

THE OUTLOOK ON MOHAWK TRAIL, MASS.

The first major development on Eastern Summit was the Outlook tower and gift shop. This postcard shows the eastern approach from a beautiful curving road. Both the tower and shop were placed on the high ridge behind the actual summit area so it would dominate a traveler's view coming around the curve. The present Eastern Summit gift shop now sits on the opposite side of the road on the viewing plateau.

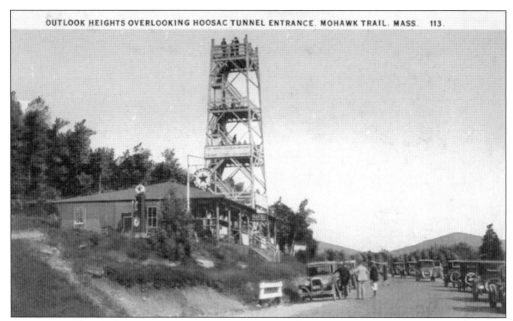

The Outlook used to have cabins for rent, but they were closed down in the mid-1990s. The tower is also gone, but the views are still exciting people. The postcard notes the Outlook Heights as overlooking the Hoosac Tunnel entrance. That would refer to the eastern entrance to the tunnel, and that is this location's claim to fame. The Mohawk Trail crosses over Hoosac Mountain at a point where at 1,060 feet directly below the trail is the, then very famous, Hoosac Tunnel.

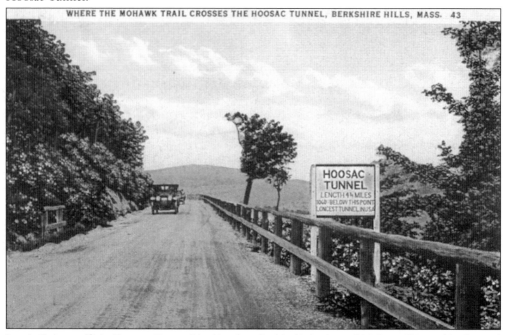

Just before reaching Eastern Summit, a sign used to indicate exactly where the Mohawk Trail crossed over the Hoosac Tunnel below. Today there are no markers on the trail as the glory days of the tunnel's importance and status are just lingering memories.

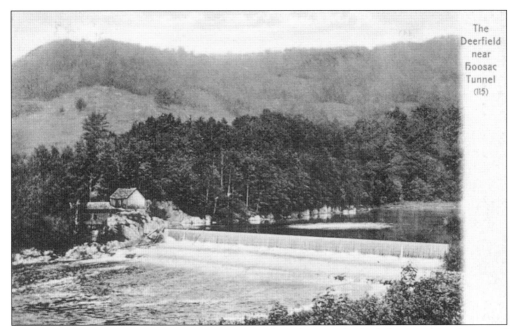

The
Deerfield
near
Hoosac
Tunnel
(115)

As the Outlook tower claimed, the view over the ridge overlooked the eastern entrance of the Hoosac Tunnel. While the portal cannot be seen from the ridge, the idea was that it was somewhere down there. This postcard displays the Deerfield River, near the eastern tunnel entrance, that would later join the Cold River on the trail farther east.

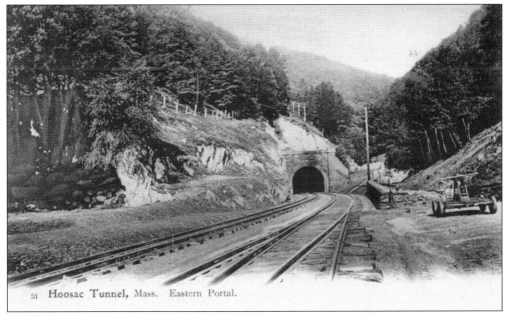

31 Hoosac Tunnel, Mass. Eastern Portal.

This is the eastern portal of the Hoosac Tunnel. The Outlook and the trail would be high on the eastern ridge of Hoosac Mountain, located up and to the left on this postcard. It was the Hoosac Tunnel that pushed the Mohawk Trail out of the spotlight and into disuse by permitting access through the mountain rather then over it by the much faster, though less aesthetic, railroad.

93

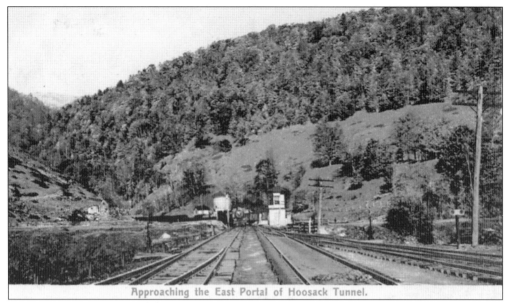

Approaching the East Portal of Hoosack Tunnel.

Approaching the east portal of the Hoosac Tunnel gives a good view of the Hoosac range in the background. From 1875, when the tunnel was completed, until 1912, not much thought and attention was given to the historic trail. Then in that year of 1912, an interest generated in North Adams gave birth to the idea of creating a new modern Mohawk Trail. The born-again trail would have yet another popular era until air travel would once again shift the traveler's priorities and take the glory of the trail with it.

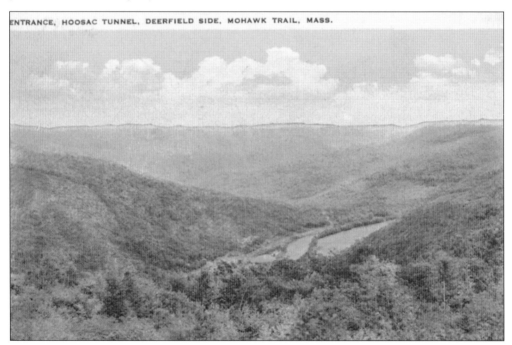

ENTRANCE, HOOSAC TUNNEL, DEERFIELD SIDE, MOHAWK TRAIL, MASS.

This is the classic view from Eastern Summit, providing a graceful mountain panorama that just seems to go on forever. The postcard again indicates the entrance to the tunnel, which in reality is somewhere below although not visible.

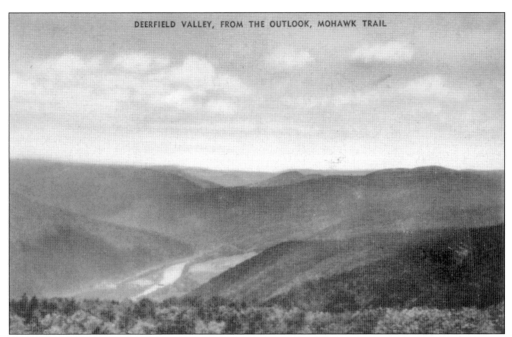

A similar view from the Outlook on Eastern Summit spreads out before the eyes the expansive dimensions of peak upon peak, finally disappearing in subtle outlines of distant ranges.

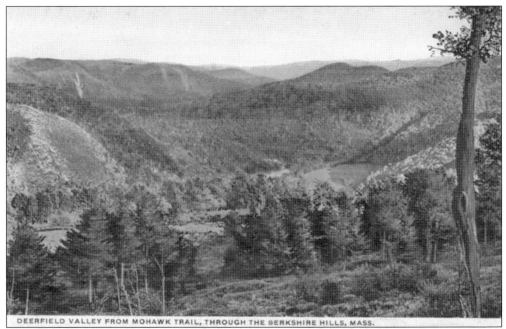

The Deerfield Valley from Eastern Summit is a vision of Eden. Thick, lush, and abundant, the wide view testifies to the trail's worth even if only in the uplifting reminder of nature's power to exhilarate the spirit.

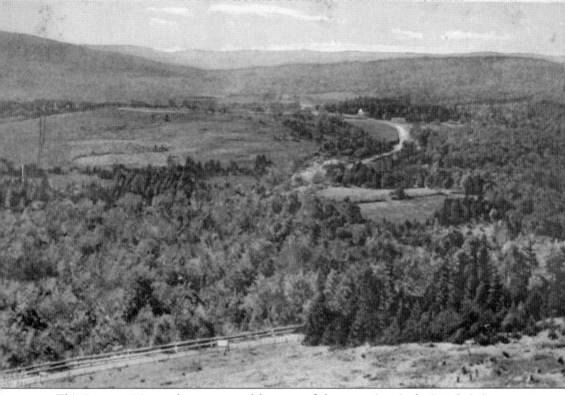

This is an exciting and rare postcard because of the rare view it depicts. It is important to remember that Hoosac Mountain is not a single ridge but double, with the elevated valley between the double ridges. Western Summit and Whitcomb and Eastern Summits (eastern ridge) are the two high points of the Hoosac range. This unique and impressive view is from Moore's Summit, a little-known ridge located in between Whitcomb Summit and Eastern Summit and accessed by Moore's Road. While not a well-known or famous lookout, the view is amazing, as it provides a detailed and captivating scene of the western Hoosac ridge in the distance and the entire valley and Mohawk Trail that lies between the western and eastern ridges.

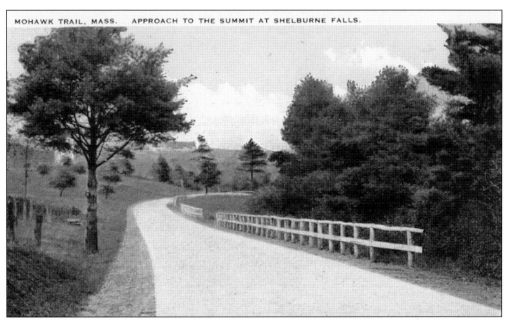

Heading down both the eastern ridge and the descending trail, the next summit meeting will take place in Shelburne Falls. This postcard shows the continued scenic beauty on the approach to the summit. The Mohawk Trail first climbs then descends again into the town. Shelburne Falls was settled in 1756. Shelburne, its neighbor village, was named after an English lord who was on the side of America during the Revolutionary War.

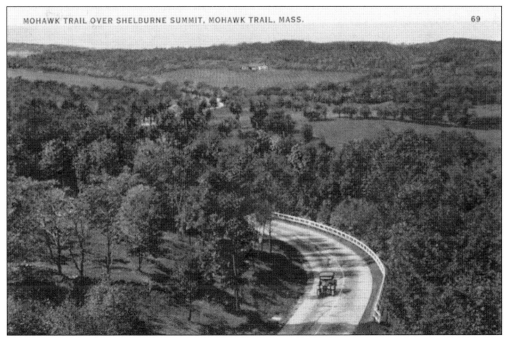

MOHAWK TRAIL OVER SHELBURNE SUMMIT, MOHAWK TRAIL, MASS. 69

As depicted on this postcard, the Shelburne summit also provided an observation tower for viewing as well as campgrounds. As with most of these towers, it no longer exists, but during the 1930s, a wonderful view of Greenfield could be purchased for the price of a cup of coffee.

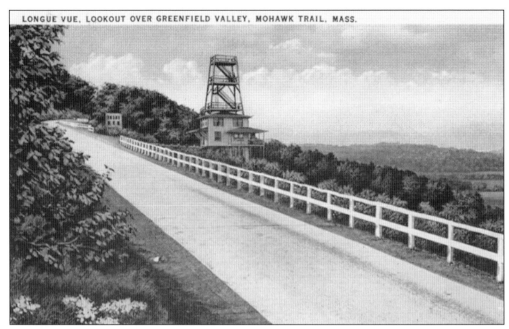

The modern Mohawk Trail reaches its eastern entrance or exit in the town of Greenfield. Settled in 1686, the town is nestled between the mountains and rivers and was the scene of much Native American activity. It affords the traveler one more popular lookout summit by the name of Longue Vue.

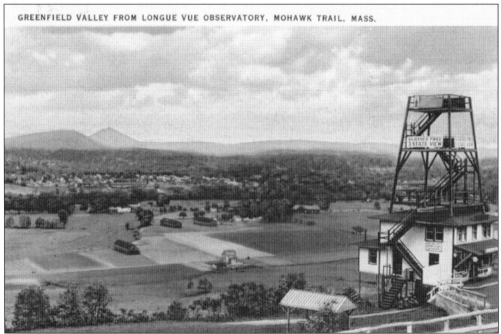

GREENFIELD VALLEY FROM LONGUE VUE OBSERVATORY, MOHAWK TRAIL, MASS.

Longue Vue (Long View) began its history in 1923. It presents a gift shop, family activities, and, of course, the observation tower for more exciting valley views. It can boast of possessing the only full-size observation tower on the trail at the present time. This postcard depicts the northern long view of the Greenfield and Connecticut River valley.

Seven

A Bridge Never Too Far

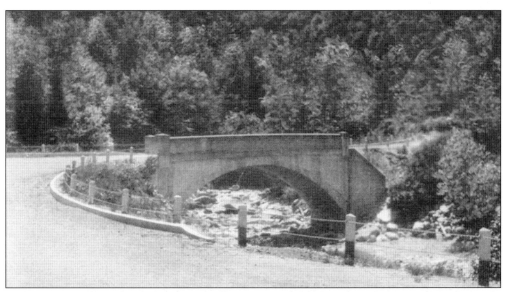

Historians state the Native American footpaths stayed fairly close to or on the riverbanks along the trail. The environmental conditions would most likely have determined where they chose to cross over a river. The European settlers had a different philosophy and approach to nature. Want to cross a river? Build a bridge. The natives listened to nature, and the settlers ignored or went around or over it. And so there are bridges on the Mohawk Trail. From Western Summit in the direction of Greenfield, the first major bridge encountered is the Cold River Bridge that connects the towns of Florida and Savoy. This postcard shows the sharp turn onto the first Cold River Bridge.

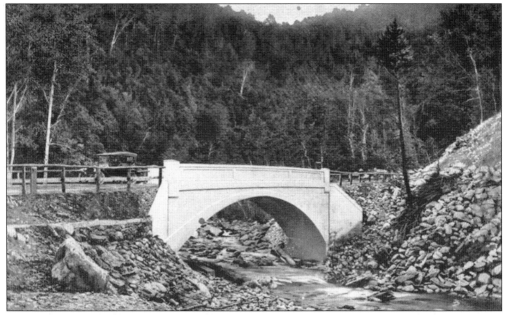

The Cold River Bridge is a narrow concrete bridge that was reconstructed in 1955 and eliminated the trail approach that was not only sharp but dangerous. If an automobile skidded on the sharp turn, a wall of rock was waiting to stop it. Reconfiguring the road and the bridge made for a safer and less-intimidating approach.

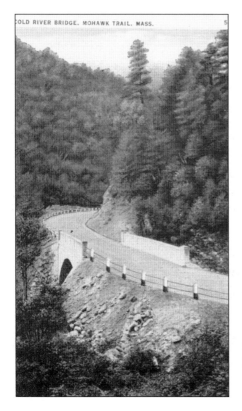

The simple, clean design of the Cold River Bridge blends in with the wilderness and fits the contours of the narrow confines where the waters of the rushing Cold River hug the trail.

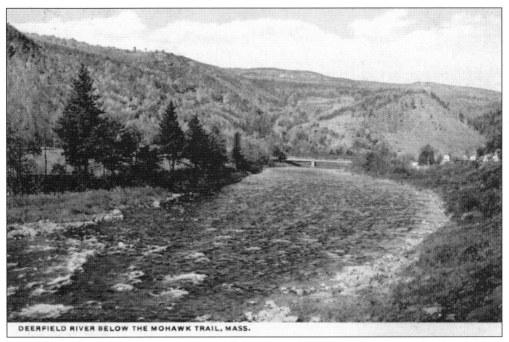

DEERFIELD RIVER BELOW THE MOHAWK TRAIL, MASS.

After the Cold River merges with the Deerfield River, a longer expansion is needed for crossing, as seen in this postcard view showing the wider Deerfield River just below the trail.

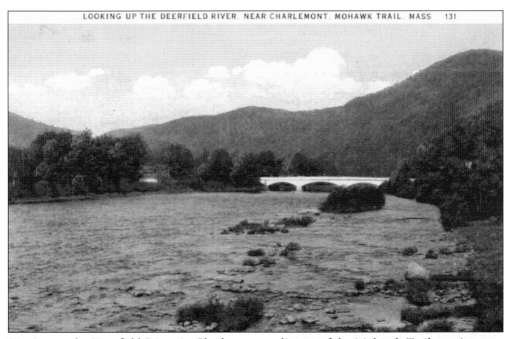

LOOKING UP THE DEERFIELD RIVER. NEAR CHARLEMONT. MOHAWK TRAIL. MASS. 131

Moving up the Deerfield River in Charlemont, a glimpse of the Mohawk Trail crossing over the river via a long bridge emerges. This structure would go by several names through the years. Today it is known as the Mohawk Indian Bridge.

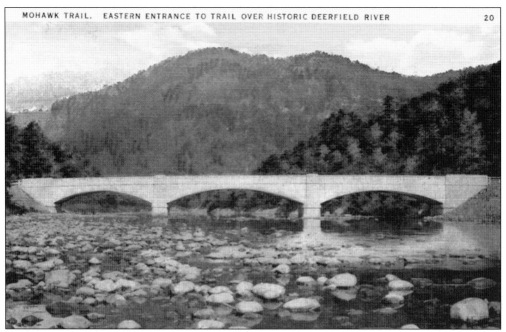

A closer view shows the beauty of the long bridge. As noted on this postcard, this bridge was considered at the time as the eastern entrance to the Mohawk Trail. This original 1914 bridge would later be replaced by a wider steel version in 1955.

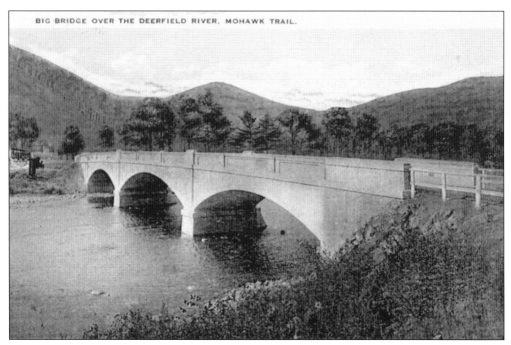

This postcard labels the structure as the "Big Bridge." Because of its close proximity to Moses Rice's first settlement and the road of the settlers (the Shunpike Road), it is also referred to as the Shunpike bridge.

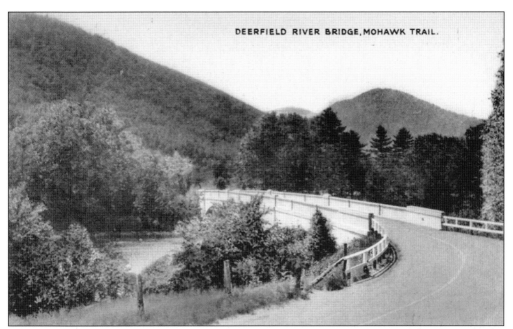

This postcard uses yet another name—the Deerfield River bridge. As mentioned, a wider steel bridge would replace this one, and today the sharp turn as seen here onto and off the bridge has been replaced by a straight road. The road seen on this postcard still exists as a side path off the main road.

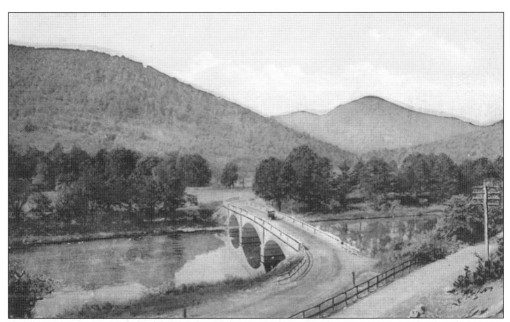

To commemorate the trail's theme, the bridge is now the Mohawk Indian Bridge, and at each end of the modern version on both sides of the road resting atop of each of the bridge's arms is a sculptured bust of a Native American. Also, Mohawk Park is located on the right side of the road across the bridge in this image, and on the left side is the landmark *Hail to the Sunrise* statue, which is featured in chapter 8.

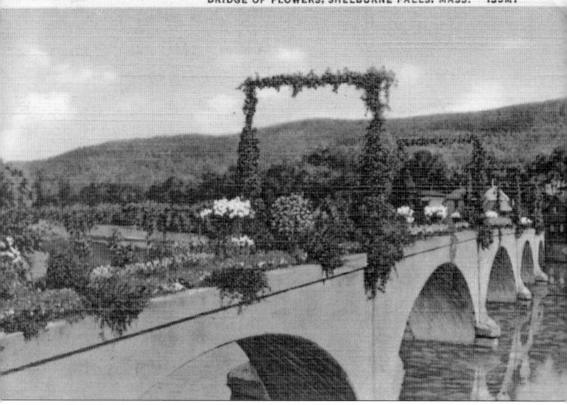

Further modifications of the 1914 trail continued through the 1960s. Several bypasses were constructed for speed and convenience. One of the prettiest towns to lose its position on the original 1914 trail due to a bypass was Shelburne Falls. Here were the old fishing grounds of the Pocumtucks. Here, also, is the most unique bridge on the trail. The famous Bridge of Flowers is 400 feet long. It was once a trolley bridge. Now it is planted with hundreds of flowers and has been maintained by the Shelburne Falls Women's Association since 1929. The bridge and the town are definitely worth the short side trip off the bypass.

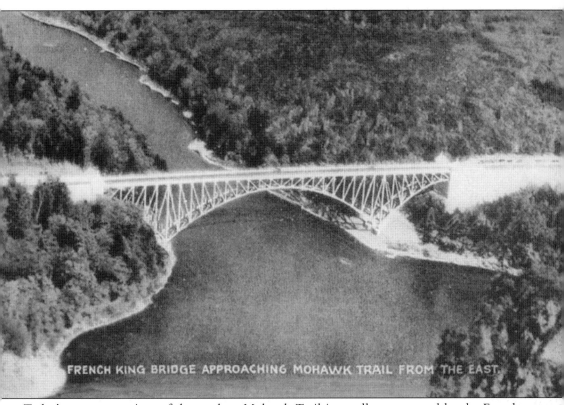

FRENCH KING BRIDGE APPROACHING MOHAWK TRAIL FROM THE EAST.

Today's eastern terminus of the modern Mohawk Trail is usually represented by the French King Bridge, which spans the Connecticut River. The west end of the bridge is in the town of Gil and the east end in the town of Erving. This bird's-eye view gives a good sense of its size—782 feet long. The famous French King Rock is where French explorers claimed the territory for the king of France. The actual rock is sometimes visible at low water. This location along with Fort Massachusetts at the western end of the trail are the only known areas where the French flag was flown in Massachusetts.

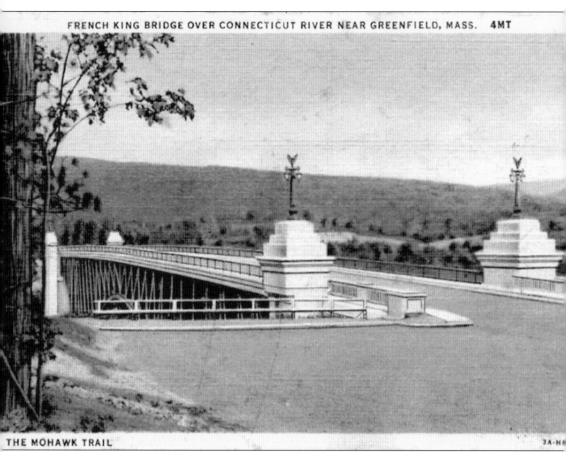

THE MOHAWK TRAIL

Acting as both the beginning and the end of the Mohawk Trail, the French King Bridge was built in 1932. The steel arch bridge is 140 feet high and was claimed to be the highest in the East. It received a citation as one of America's most beautiful bridges.

Eight

THE MOHAWK
AND THE ELK

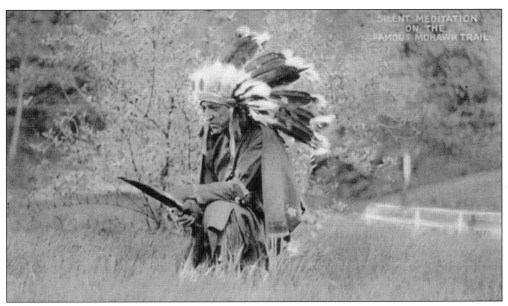

SILENT MEDITATION
ON THE
FAMOUS MOHAWK TRAIL

The history of the Mohawk Trail is foremost a part of the history of the ancient Native Americans who in past epochs inhabited the valleys from the Hudson River to the Connecticut River. The most famous monument on the trail is appropriately dedicated to the Native Americans (and in particular the Mohawks). This postcard portrays a real Native American (it is assumed) in meditation on the trail. In time, people thought a statue commemorating the Native American should be placed on the trail. The first attempt was made by the nonnatives, but it failed to produce the statue. The second attempt by the Native Americans succeeded.

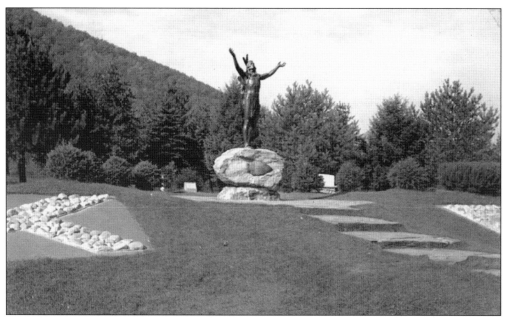

In 1913, the Mohawk Trail Committee in North Adams tried to raise money for a Native American statue to be placed on the trail. To raise the funds, the organization staged a historic pageant in North Adams. It took place in June 1914 with a cast of historic characters numbering around 1,100. Although the pageant was a great theatrical success, the cost of the production nullified the amount raised. The eventual statue, as seen in this postcard, would come from an equally determined source.

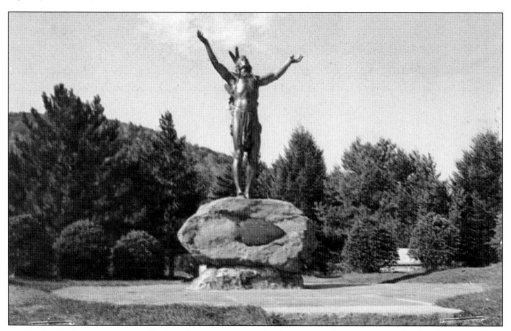

In 1932, the bronze statue *Hail to the Sunrise* was finally erected just west of the Mohawk Indian Bridge in Charlemont. It was accomplished by the Improved Order of the Redmen and its women's auxiliary, the Allied Councils of Pocahontas of the Old Deerfield Conference.

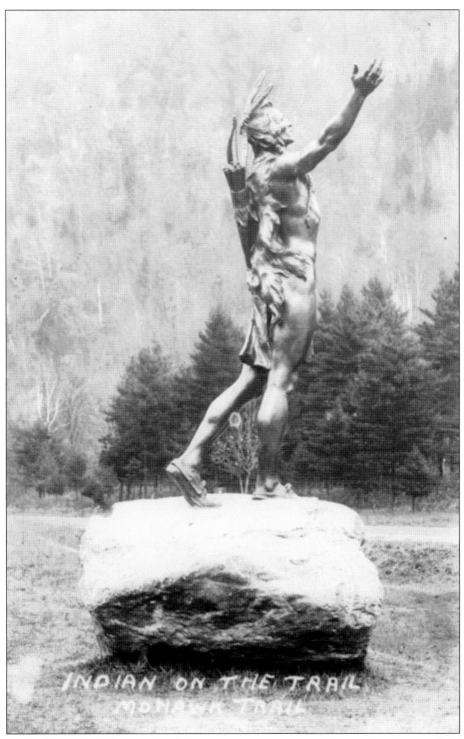

The eight-foot-tall *Hail to the Sunrise* bronze statue was created by sculptor Joseph Pollia of New York City and was unveiled on October 1, 1932. The stone foundation was dedicated on September 23, 1935.

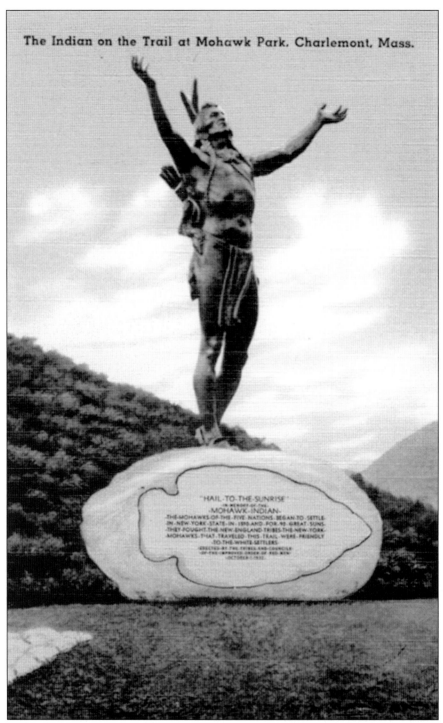

The Indian on the Trail at Mohawk Park, Charlemont, Mass.

The arrowhead plaque reads, "'Hail to the Sunrise / In Memory of the Mohawk Indian / The Mohawks of the Five Nations began to settle in New York State in 1590 and for 90 great suns they fought the New England tribes. The New York Mohawks that traveled this trail were friendly to the white settlers."

The Mohawk Trail's first major monument was *The Elk*. It was erected on Whitcomb Summit in 1923. It is a memorial to Massachusetts veterans killed in World War I. It was created by well-known sculptor Eli Harvey.

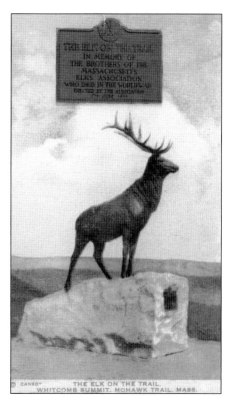

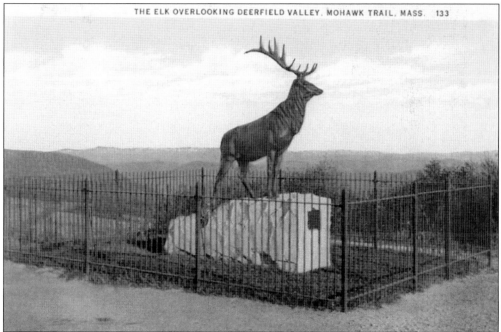

The Elk was unveiled in front of some 10,000 observers on June 17, 1923. The statue was paid for by the Greenfield Lodge of the Benevolent and Protective Order of the Elks along with other lodges from across the state that made later contributions.

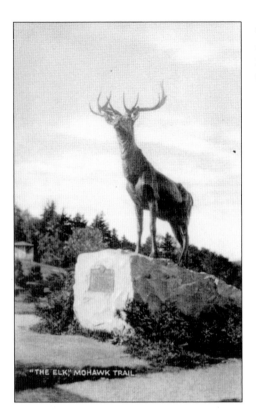

The land for *The Elk* was donated by Charles Canedy, who was manager of Whitcomb Summit at the time. The deed gives the land it sits on to the National Order of Elks.

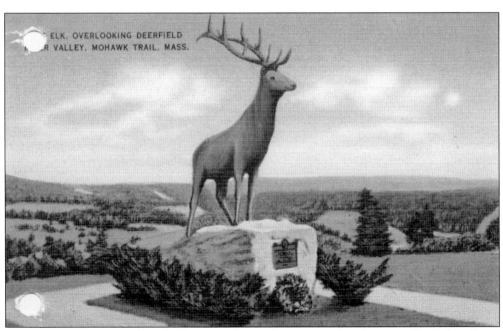

The Elk greets travelers from both east and west directions. The plaque reads, "The Elk on the Trail / In memory of the Brothers of the Massachusetts Elk Association who died in the World War."

Nine

TRAIL MIX

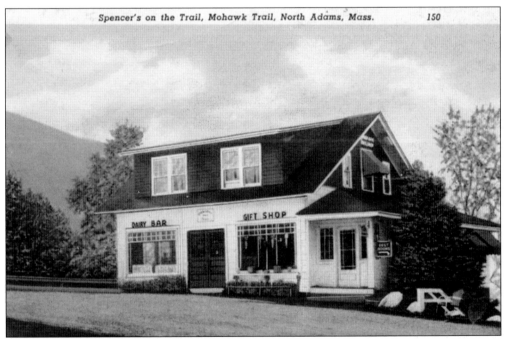

Spencer's on the Trail, Mohawk Trail, North Adams, Mass. 150

The modern Mohawk Trail's opening in 1914 and the renewed popularity that ensued created many opportunities for businesses from motels to gift shops. Besides the obvious summit locations covered in previous chapters, many small, private, family-run businesses also cropped up along the trail. Spencer's gift shop and snack bar was one of them and was one of the first encountered on the trail after leaving the city center of North Adams heading east. It was located on the slope leading up Hoosac Mountain just before the famous Hairpin Turn. Today a trailer park occupies the location.

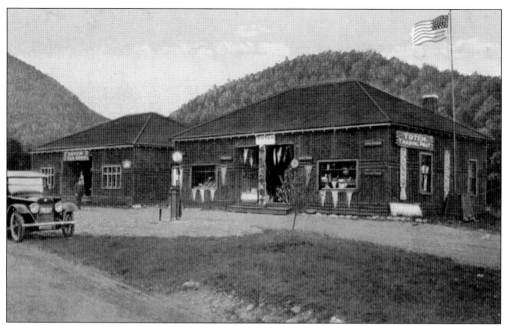

In Charlemont, near the entrance to the state forest campgrounds, once stood the Totem Trading Post and Tea Room. This 1920s postcard shows the two buildings. The one on the left is the tearoom, and the one on the right is the trading post. Native American–themed businesses were always very popular and still are on the trail.

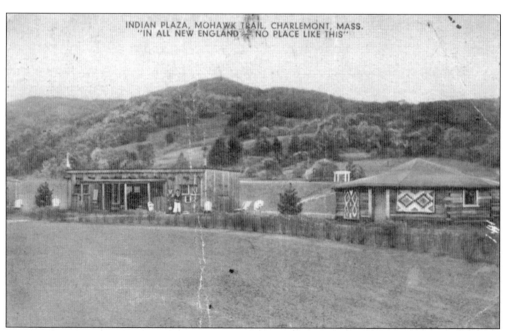

One of the largest and most enduring of the Native American–themed stops is the Indian Plaza. It opened in the early 1930s and was instantly popular. It offers Native American arts and crafts. It can still be found in East Charlemont on the trail.

The Indian Plaza's owners had a Navajo silversmith named Da-Pah from the Navajo reservation in New Mexico create this Navajo dance figure. It is called *Yei-Ba-Chai*. It was erected in 1947, and it commemorates the famous "night chant" dance of the Navajo people.

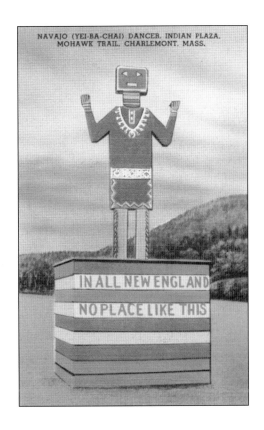

Da-Pah also created this Navajo hogan in 1933 at the Indian Plaza. The hogan can still be seen at the site.

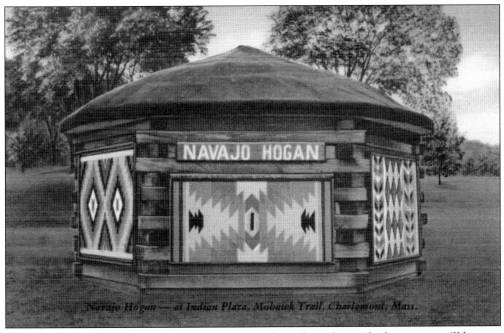

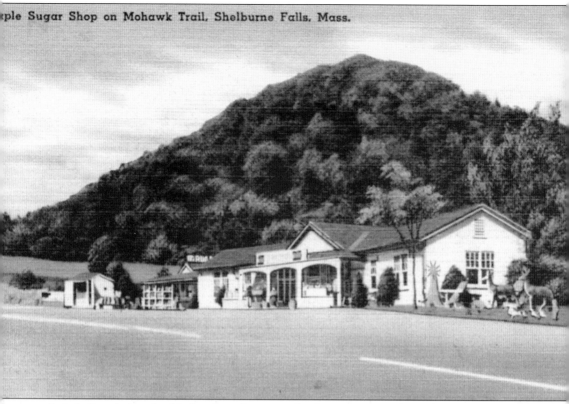

It is believed that the Native Americans taught the Europeans the skill of maple sugaring, and the techniques have changed very little since. Over the years, the Mohawk Trail has had a number of maple sugar houses and shops. This postcard shows one that once existed in Shelburne Falls on the trail.

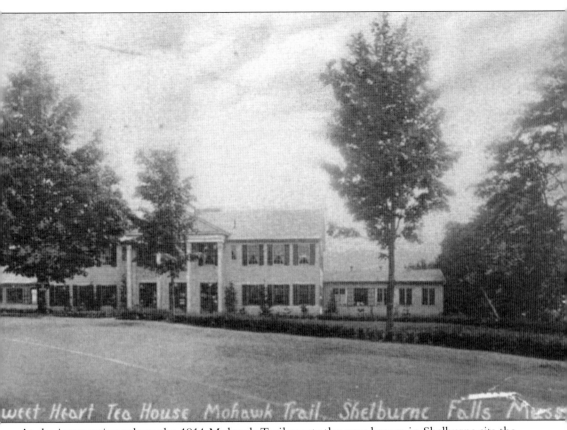

weet Heart Tea House Mohawk Trail, Shelburne Falls Mass

At the intersection where the 1914 Mohawk Trail meets the new bypass in Shelburne sits the wonderful and charming Sweet Heart Tea House. It has been there since 1915 when Alice Brown made maple sweethearts in the upstairs of her home and then placed a sign to advertise—"Stop for Your Sweetheart." In time, the idea spawned a successful teahouse and restaurant.

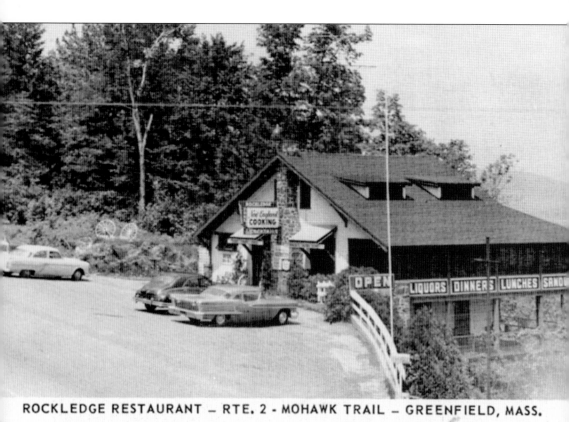

ROCKLEDGE RESTAURANT — RTE. 2 - MOHAWK TRAIL — GREENFIELD, MASS.

This Rockledge Restaurant rested on a rock ledge overlooking the Greenfield and Connecticut River valleys. It was situated on the trail in Greenfield close to Longue Vue Summit. It advertised "a meal with a three state view." Today the empty building still sits on the ledge. The "view without a meal" remains the same.

Ten

HAPPY TRAIL TO YOU

Being a popular vacation and recreation destination from 1914 to the 1950s, the Mohawk Trail left behind a wealth of printed material from that era that once advertised the trail's immense interest. It includes guidebooks, pamphlets, history booklets, souvenir books, coloring books, and postcard packets, along with the single postcards featured in this book. The packet shown here contains 20 two-inch-by-three-inch miniature views of the trail, many of which can be seen in this book as postcards.

This small pamphlet (two inches by six inches) contains the program for the pageant of the Mohawk Trail that was performed in North Adams in June 1914 for the purpose of raising money for a Native American statue on the trail. As noted previously, the successful pageant did not generate enough money to outweigh the costs. But by all accounts, it was quite a show with around 1,100 reenactors participating in the event.

This postcard-size advertisement card notes the time and location of the pageant. It was in Valley Park in North Adams from June 17 to June 20, 1914. The pageant portrayed historic events that occurred along the Mohawk Trail from the 17th century to the then present time of 1914.

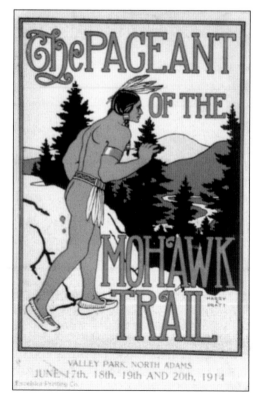

The complete program for the pageant of the Mohawk Trail is contained in this booklet along with an extensive history of the trail. It covers the historical episodes and contains a complete list of all who participated in the pageant program. The booklet also has a number of interesting photographs and includes the next three images, which are very relevant to this book.

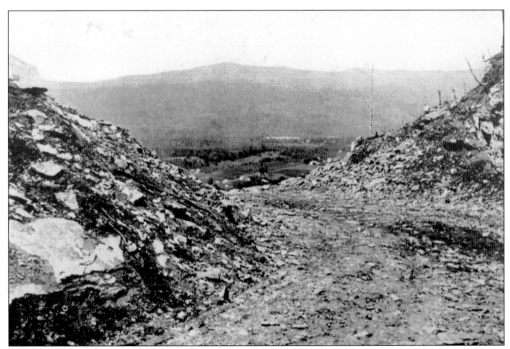

This is the initial rough cut of the famous Hairpin Turn on the western side of Hoosac Mountain (compare with images in chapter 3).

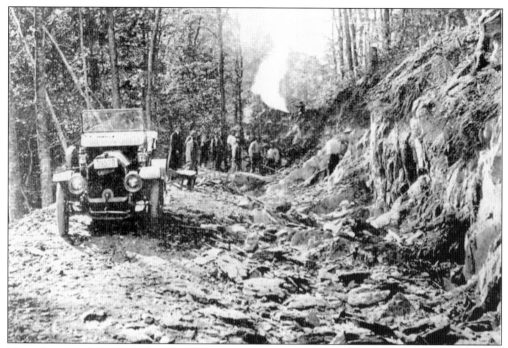

This photograph is labeled as the first car over the Mohawk Trail, said to have occurred on June 5, 1914, by a *North Adams Transcript* photographer, Charles Canedy.

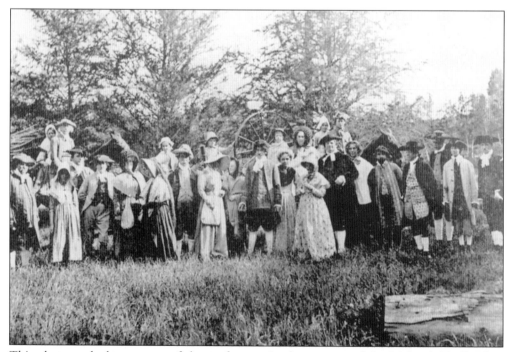

This photograph shows some of the performers in the pageant of the Mohawk Trail. They represent the "First Settlers of the Hoosac Valley," portrayed by lineal descendants. It indicates how professional the pageant was and why as a theatrical event it was very successful.

This beautiful textured booklet (three inches by five inches) contains the menu for the banquet of the Mohawk Trail dedication on October 22, 1914, which was held at the Richmond-Wellington Hotel. Some highlights include oyster cocktail, ramekin of sweetbreads with fried mushrooms, spring chicken southern style, punch Renaissance, and Neapolitan ice cream.

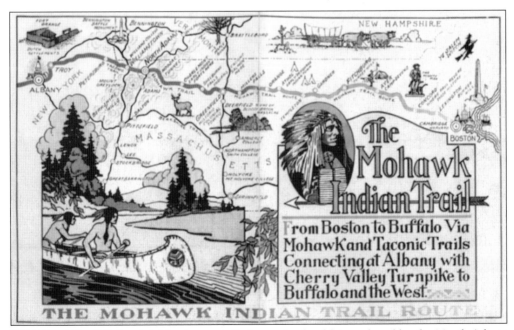

This shows the full front and back cover of a large-size booklet produced by the North Adams Chamber of Commerce around 1930. It contains photographs of many of the places of interest along the trail.

This shows the front cover of a souvenir booklet with many of the postcard scenes used in this book. It was published in 1938.

A Trip over the Mohawk Trail was a large-format (9 by 11 inches) photographic souvenir book. It contains stunning black-and-white photographs of the trail that were also used as postcard scenes.

The Trail of the Mohawk guidebook was produced by the photographer Charles Canedy, who also operated Whitcomb Summit and drove the first car over the trail. It contains many of the postcard scenes in this book and also has advertisements for many of the businesses on or near the trail.

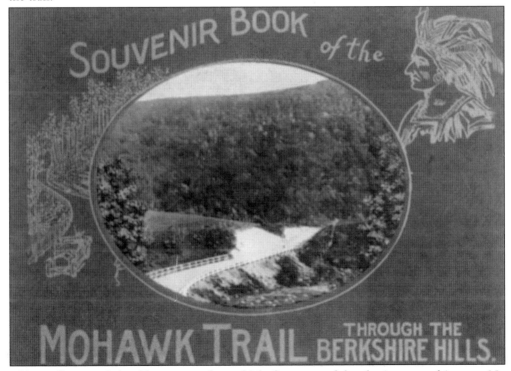

This small souvenir booklet was another vehicle for many of the classic postcard images. No publication date exists, but it was probably published around the 1920s.

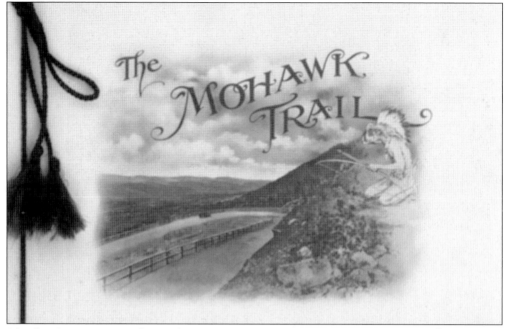

This handsome cover is from a history and photograph book published by Frank Martin in North Adams around 1914. The cover shows the Hairpin Turn and all the inside images are a beautiful sepia tone.

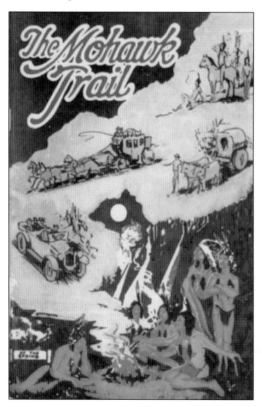

This Mohawk Trail book was written by William Browne in 1920. It contains an extensive detailed history of the trail and accounts of Fort Massachusetts.

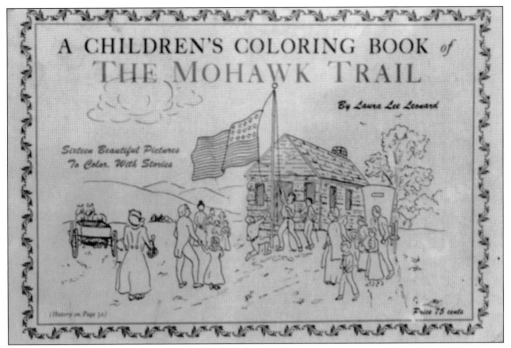

This charming children's coloring book by Laura Lee Leonard was published in 1952. It was much more than a coloring book as it also provided history and stories connected with the Mohawk Trail.

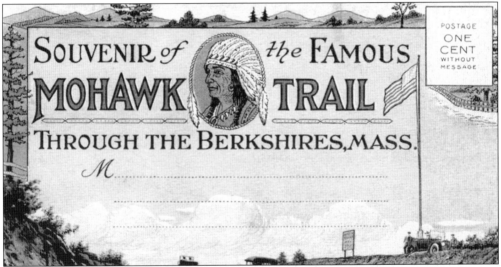

National Geographic selected the modern Mohawk Trail as one of the 50 most scenic routes in the United States. It has also been noted that in the early years of the trail, many newlyweds selected the Mohawk Trail as their honeymoon destination. This large postcard-size packet contains 22 scenes of the trail. Notice the message where the stamp is placed—"Postage One Cent Without Message." (How much with a message?) Who needs a message when a postcard picture is worth a thousand words and the Mohawk Trail experience is worth at least a thousand memories. As a poem from a 1930s guidebook says, "You may roam where fancy leads you over hill and dale. But you haven't seen America 'till you've seen the Mohawk Trail."

Across America, People are Discovering Something Wonderful. *Their Heritage.*

Arcadia Publishing is the leading local history publisher in the United States. With more than 3,000 titles in print and hundreds of new titles released every year, Arcadia has extensive specialized experience chronicling the history of communities and celebrating America's hidden stories, bringing to life the people, places, and events from the past. To discover the history of other communities across the nation, please visit:

www.arcadiapublishing.com

Customized search tools allow you to find regional history books about the town where you grew up, the cities where your friends and family live, the town where your parents met, or even that retirement spot you've been dreaming about.